snapshot
poetics

snapshot
poetics

a . photographic . memoir . of . the . beat . era – allen . ginsberg .
edited . and . introduced . by . michael . köhler – chronicle . books – san . francisco .

FIRST PUBLISHED IN THE UNITED STATES IN **1993** BY CHRONICLE BOOKS.

PRINTED IN SINGAPORE.

EDITORIAL NOTE

SNAPSHOT POETICS WAS ORIGINALLY PUBLISHED IN GERMANY AS **REALITY SANDWICHES.**
IN THE GERMAN EDITION MICHAEL KÖHLER'S INTRODUCTION WAS MERGED WITH ALLEN GINSBERG'S DISCUSSION
OF HIS PHOTOGRAPHY. FOR THIS AMERICAN EDITION, MICHAEL KÖHLER'S INTRODUCTION
HAS BEEN EDITED IN ORDER TO PRESENT ALLEN GINSBERG'S DISCUSSION
OF HIS PHOTOGRAPHY IN ITS ENTIRETY. THE GINSBERG TEXT IS DERIVED FROM AN INTERVIEW CONDUCTED BY
MICHAEL KÖHLER AT THE POET'S NEW YORK APARTMENT IN THE FALL OF 1988.

THE PHOTOGRAPHS THAT APPEAR IN THIS VOLUME HAVE BEEN LITHOGRAPHICALLY REPRODUCED FROM PRINTS
PREPARED FOR ALLEN GINSBERG BY SID KAPLAN AND BRIAN GRAHAM IN NEW YORK.
THE PRINTS WERE TAKEN FROM ORIGINAL NEGATIVES AND HAVE NOT BEEN CUT OR TRIMMED.
THE CAPTIONS WERE WRITTEN BY THE PHOTOGRAPHER. THE ORDER IN WHICH THE PHOTOGRAPHS ARE REPRODUCED
IS LARGELY CHRONOLOGICAL.

LIBRARY OF CONGRESS CATALOGING IN PUBLICATION DATA

GINSBERG, ALLEN, 1926 –
[REALITY SANDWICHES]
SNAPSHOT POETICS: ALLEN GINSBERG'S PHOTOGRAPHIC MEMOIR OF THE
BEAT ERA / ALLEN GINSBERG: INTRODUCTION BY MICHAEL KÖHLER.
P. CM.
TRANSLATION FROM THE GERMAN.

ISBN 0-8118-0372-4 (PBK.)
1. GINSBERG, ALLEN, 1926- FRIENDS AND ASSOCIATES — PORTRAITS.
2. AUTHORS, AMERICAN – 20TH CENTURY – PORTRAITS. 3. BEAT GENERATION —
PICTORIAL WORKS. I TITLE.
PS3513.I74Z475 1993
810.9' 0054—DC20
[B] 92-40516
CIP

EDITOR: MICHAEL KÖHLER
BOOK AND COVER DESIGN: U-CEF HANJANI
COVER PHOTOGRAPHS: ALLEN GINSBERG
INTRODUCTION EDITOR (AMERICAN EDITION): STEVE SILBERMAN
BIO- AND BIBLIOGRAPHICAL UPDATES: SIMON PETTET

DISTRIBUTED IN CANADA BY
RAINCOAST BOOKS
112 EAST 3RD AVENUE
VANCOUVER, B.C. V5T 1C8

10 9 8 7 6 5 4 3 2

CHRONICLE BOOKS
275 FIFTH STREET
SAN FRANCISCO, CALIFORNIA 94103

tents

It was in the spring of 1957 that the name Allen Ginsberg first came to public attention. A judge in San Francisco was asked to decide whether his poem *Howl* should be banned on charges of obscenity. This in itself was quite a sensation. But even more unusual was that the literary qualities of the poem were never in question; indeed, it was clear that its voice was new and original. In fact, it was so savage in its indictment of the America of the time that the public became curious about what might have caused the anger expressed in *Howl*, an anger of such intensity that it assumed almost biblical proportions.

The picture became somewhat clearer the following autumn with the appearance of another new book, the novel *On the Road*, which caused a comparable stir. It emerged that its author, Jack Kerouac, not only was a close friend of Ginsberg's, they were also part of a larger group of young writers from New York and San Francisco who had joined forces in open rebellion against the prevailing mood of the times.

When Kerouac coined the term *beat generation* for that group of writers, he was thinking of the way the word was used in the drug scene, where it meant "worn out, finished, without any hopes or illusions." They had known the horror of World War II, sensed the insanity of the atom bomb, suffered from the oppressive sense of conformity that dominated the America of the Cold War, and concluded that this society no longer had any prospects to offer them—which meant that the only way open to them was to completely drop out from this society, the course described in *On the Road*.

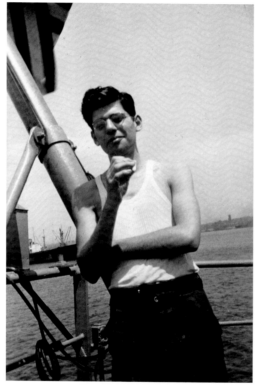

ALLEN GINSBERG, UTILITY-MAN S.S. JOHN BLAIR AROUND OCTOBER 30, 1947, JUST BACK IN N.Y. HARBOR FROM GALVESTON-DAKAR DOLDRUMS TRIP, I HANDED MY CAMERA TO THE RADIO-MAN ON THE SHIP'S FANTAIL, SMOKING WHAT?

Its heroes pursue a concrete utopia that is the archetypal American Dream of a life beyond bourgeois conventions. Under contemporary conditions this meant a life of freedom and fast living, a life that was high on jazz and drugs, on sex and visionary experience.

This explains why the word *beat* also came to mean a thirst for adventure, the feeling of comradeship, and a longing for happiness or beatitude, a divine intoxication sought, not as an end in itself, but as a means of access to mystic knowledge in the tradition of Buddhist enlightenment and Christian redemption.

As a statement of individual self-liberation, the message of the Beat Generation struck a chord with many young Americans at the end of the 1950s and consequently served as a model for whole generations of rebellion around the world—from the beatniks and hippies of the 1960s to the punks of the 1970s and the grunge subculture of the 1990s.

The legend of the Beat Generation continues to flourish as never before. Though its heroes may have grown old, they have certainly not grown tired—quite the opposite.

With the exception of Kerouac and Neal Cassady, both of whom died at the end of the 1960s, they have all led long and honorable lives, as well as remained productive. Almost all are still publishing, some with impressive regularity, others even with New York's major publishing houses. Works such as *On the Road*, *Howl*, and *Naked Lunch* are not only the staple diet of American universities;

secondary literature on the subject, including extensive biographies, is now a thriving industry. It might almost be thought that the contempt the literary establishment initially felt for the Beats had now given way to something approaching a warm embrace.

But the former rebels have not yet been as smoothly assimilated as this picture might suggest. To stick with Ginsberg: for the last six years a professorship at Brooklyn College at a generous annual salary and the prospect of a pension has ensured his financial independence. In addition he enjoys a not inconsiderable income from public readings of his works both at home and abroad; his fee for an evening may amount to as much as $5,000. And he receives more offers than he can ever accept. In addition, he contracted with the New York publishing giant Harper Collins to publish his *Collected Poems*, to be followed by five volumes of collected works as soon as further manuscripts of his poems, diaries, essays, interviews and letters were ready for publication. He's served as vice-president of the American Pen Club, and is a member of the American Academy of Arts and Letters, the most highly regarded official literary institution in the United States, he has been sent on tour to the People's Republic of China and the former Soviet Union. Does this mean that he has succumbed to the lure of the culture industry and become untrue to himself? Ginsberg himself replies to this question in the 1980s:

"As before, the image which the media show of me today has little to do with actual reality. Only the clichés have changed. Before, I was the bogey of the middle classes; today I'm either a yuppie or a grandpa losing his inspiration. But why should I get worked up? Why waste time on others' bad poetry?"

And so, as before, he dabbles in politics, taking part in demonstrations against nuclear power and in support of ecological issues, signing resolutions against the American "war on drugs" policy, and making over considerable sums of money to various civil rights and Buddhist organizations in keeping with his motto of "Better to give than pay taxes."

His lifestyle, too, has changed little compared with what it used to be. He continues to buy his clothes from the Salvation Army, for example, even if those clothes now include neckties, white shirts, and dark suits. And his apartment—four rooms with a kitchen and bathroom for several hundred dollars a month—is still on the Lower East Side, just as it was some thirty or forty years ago. It is just as luxurious now as it was then.

What has increased most of all is his daily workload, with a far greater number of public engagements and a commensurate volume of correspondence, including office and traveling expenses and more or less regular grants to support the financially less successful first-generation Beats. For one of Ginsberg's most remarkable characteristics is the loyalty with which he maintains old friendships, remaining interested in old colleagues' continued writing, reading through their work when possible and encouraging their publication.

In this respect his New York apartment and new office has continued for decades to be a kind of permanent literary salon, a meeting place and unofficial agency for the Beat Generation, but also a popular and well-tried testing ground for young and talented writers, as well as a general mine of information about literary activities on the Lower East Side and elsewhere. The result is a constant stream of visitors of every type and description, as is clear from photographs taken during the 1980s.

The following discussion was held at the very place where many of these portraits were taken, the kitchen table in Ginsberg's apartment, with its view over the courtyard at the back of the building (see page 51). For Ginsberg it was the end of a very long day that had begun with a lecture at Brooklyn College, followed by a meeting with his French translator, after which he had accompanied his Russian translator on a shopping expedition before attending an early evening reception to say good-bye to a delegation of poets from the People's Republic of China to whom he had read poems a few days earlier at the Museum of Modern Art. When we finally sat down at the kitchen table to talk about his photographs, it was already nearly midnight. ▶

MICHAEL KÖHLER

My picture taking goes back to 1945 or 1946, when I got my own box camera and took a bunch of pictures with Burroughs, his wife Joan, Kerouac, and Hal Chase. I must have still had that camera in '47, because I took a couple of pictures of Herbert Huncke and Burroughs on their Texas marijuana farm. But I really didn't get into picture taking until 1953, when I went to a 3rd Avenue second-hand store and bought a Kodak Retina for thirteen dollars and began taking several rolls at a time.

I still remember that I was frightened of the Rolleiflexes; they seemed like big, complicated machines, and I thought I'd never understand how to work one. Also, they were expensive and looked professional, and I wasn't ready for that. So, I bought the

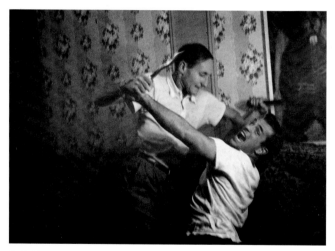

BILL BURROUGHS AND JACK KEROUAC LOCKED FOR A SECOND IN MORTAL COMBAT, MOROCCAN DAGGER VERSUS BROOMSTICK CLUB ON THE LIVING ROOM COUCH 206 EAST 7TH STREET APARTMENT 16, FALL 1953, JACK CAME IN FROM RICHMOND HILL, BILL WAS LIVING WITH ME ASSEMBLING AND EDITING "IN SEARCH OF YAGE" LETTERS FROM ECUADOR.

Kodak Retina; it was small, it fit into my breast pocket, and it didn't seem like such a big deal. Taking pictures with it was easy too—I simply followed the directions on the film wrapper about exposure time and guessed the aperture and distances.

I ordered the prints through a drugstore on Tompkins Square, a few blocks away from here (East 12th Street, N.Y.) and within a week or so they would give them back. I was really pleased with them, and would take more rolls. Then I found that I could take pictures indoors as well. I had to rest the camera on a chair because it took a full second exposure with the slow films of those days.

We all enjoyed fooling around with the Kodak Retina in the fall of '53 when Burroughs was staying at my apartment and Jack came to visit us frequently. The photo sessions never lasted for more than five or ten minutes, though. We did them while we were in the middle of other matters, like writing or just gossiping, so the picture taking was not very conspicuous at the time, or unusual. Not even the semi-nudes I took of Bill—just intimate.

Bill and I were having an affair then, and I think he was pleased that I would want to take his picture nude from the waist up (he had his underwear on). I was taking advantage of the intimacy as an excuse to invade his privacy, take him more naked than he would normally show himself.

What *was* unusual though was the trust of our relationship. We took it for granted that the world was a little crazy if it saw our friendship and sense of sacramental respect for each other to be neurotic, sick, weird, or strange.

You see, the mutual respect between us was contrary to what was taken for emotional and psychological reality in those days. It was the beginning of the "American Century," the beginning of hyper-militarisation, of the Atomic Era and the Age of Advertising, of Orwellian double-think public language. The candor of tenderness which Bill and I expressed to each other seemed different from the "square" mentality of public discourse.

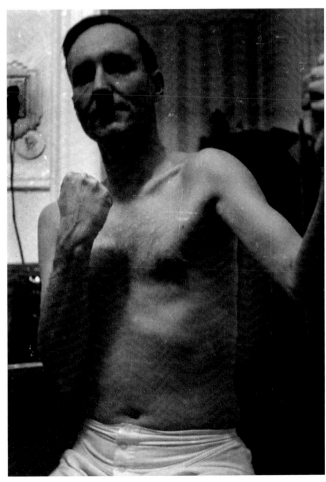

WM. S. BURROUGHS BESIDE KITCHEN TABLE NEXT TO TYPEWRITER GETTING IN CONDITION TO EDIT
HIS SOUTH AMERICAN YAGE & QUEER LETTERS, MSS TO BE PUBLISHED DECADES HENCE,
IMMORTALITY COMES LATER. WE SLEPT IN REAR, STRIPED-WALLPAPER'D TINY BEDROOM WOODEN
WARDROBE VISIBLE BEHIND LEFT SHOULDER, EAST 7TH STREET N.Y. FALL 1953.

So, what was my motivation to take these pictures in those days, apart from the fun while taking them?

Well, I had a sacramental sense of these friends. Soon after I met Burroughs and Kerouac in '44, I realized that they were people to learn from. Furthermore, I was in love with them both in one way or another—with Kerouac physically and with Burroughs sort of spiritually. I admired Burroughs as a seventeen-year-old boy would admire a man of about thirty years—it was almost a kind of hero worship. They were teachers to me, and I had a very strong devotional sense toward them both.

Then there was the idea of the Marx Brothers or the Three Stooges: a close-knit group of inimitable personalities that would never be forgotten.

Not that I thought we would be "famous" writers together, later on—that didn't occur to me in 1953. By then we'd known each other for almost a decade and were sort of cemented together for life already and had written our first major works, "published in heaven," not on Earth.

You see, by '53 Kerouac had written *The Town and the City, On the Road, Visions of Cody,* and *Dr. Sax,* and was writing *The Subterraneans.* He was already an accomplished supreme genius, with some of his best work already done. Burroughs had written *Junkie* and a series of letters to me that would later become *Queer* and *In Search of Yage.* He had already written three books which are now considered caviar.

Even then we didn't have a self-conscious awareness that we were important or that we'd be literarily famous. In '56 when *Howl* was published, I had no idea that the poem would go beyond the literary community of San Francisco. So, in the dedication of *Howl* I listed all the books Kerouac and Burroughs

had written, and said "all these books are published in heaven." By this I meant that Kerouac, for example, was willing to write ten to fifteen books, without having them published, for the holy purpose of confessing his soul to God, because there was no public for them here on earth.

Which is to say, my photographs from that time were similarly meant more for a public in heaven than one here on earth—and that's why they're charming.

So I took the pictures primarily because of the direct contact with beautiful faces—because, you see, their faces were beautiful and interesting. Bill was always curious to photograph no matter what mood or face he had on. He always had some curiously interesting, strange, and secret kind of genius. He magnetized me because he was so interesting. And Kerouac was beautiful and intelligent, exquisite in his face and gestures.

SELF-PORTRAIT AFTER DAWN, UP ALL NIGHT ON ECSTASY POWDER, AUGUST 1, 1985, BOULDER, COLORADO, MIRRORED BATHROOM WALL ON MY RIGHT MEETING MIRROR IN FRONT OF ME, MAPLETON STREET HOUSE.

In that sense, I took the pictures not to show others, but as keepsakes of my own total sacramental, personal interest in intimate friends. Our success here on earth after the publication of *Howl, On the Road*, and *Naked Lunch* didn't change the motif for Snapshots.

The pictures I took in Tangier in '57 and '61 still had the character of occasional and intermittent epiphanies for me. As I left India in '63, I must have lost my Kodak Retina at some point, or perhaps I gave it to Peter (Orlovsky) when we separated, because I bought a new camera in Hong Kong—a half-frame camera—duty free, you know. A lot of pictures were taken with that camera in Japan in '63. But after I went to Vancouver for a poetry conference, I gave it away or lost it. I didn't take any more pictures until the '70s, simply because I didn't have a camera any more.

You see, I was never a big picture-taker, and I didn't consider myself a camera-man. There are only about thirty rolls from the period between '53 and '63 because at the time my interest in pictures was more sacramental than photographic. I didn't see myself as a recorder of events or as being involved in a continuous reportage.

I'm afraid that I'm more into continuous reportage now. As a matter of habit I carry a camera where I used to carry a notebook. I'm finding that I write less and less in my notebooks now—I do my sketching and observing with the camera instead. It's beginning to displace writing a bit—not the poetry, though, but the peripatetic notes I used to take. It's a little bit wrong, no doubt about it, because I'm not as good a photographer as I am a writer, and should stick to my original trade—but you see, as Robert Frank says, photography is an art for lazy people, and he's right.

Familiar with his work, I began to realize that my old pictures were valuable and historically interesting—maybe even art.

That was in 1984; and I was surprised at the idea of their "art value." A lot of them had been used for book-covers or illustrations in a number of publications, big and small. So, I did keep seeing them from time to time, but simply didn't think about them much.

You see, in 1968 I began shipping all my stuff from my father's attic in Paterson up to Columbia University. I had never pored through it all, and anybody who wanted any of those photos had to go up to Columbia and look through them themselves. I never took the time to do it myself.

In '84 I went down to teach with Robert Frank and Elvin Jones at the Atlantic Center for the Arts near Daytona Beach, Florida, where some of Robert's photos in *The Americans* were taken. He loaned me his Polaroid 195 camera, and somehow that made me begin to take the whole thing seriously in a way that I never had before.

Robert then introduced me to Brian Graham, his printer, and we decided that he should do a couple of prints from the old negatives.

At the same time I met Raymond Foye, a great archivist, curator, and editor. He knew how to handle archival objects and could understand the art aspect of my photos. He was the perfect person to go through my archives, separate everything, see what's there, and index it all. He lacked work at the time so I hired him to organize everything. For the first time, I had an opportunity to survey what had piled up over the years.

And I was very surprised by what I saw—particularly when the printing began, and I saw my old pictures enlarged to 8" by 10" or 11" by 14" for the first time. I was amazed, particularly when I saw enlargements of images I had never cared to have drugstore prints

made of, like the one of Neal (Cassady) and Natalie (Jackson) under the marquee of the movie theater. That picture was a revelation to me and I was glad that I had taken the image then and there, because Neal was the archetype of that Jimmy Dean/Marlon Brando kind of youth hero way before it became recognizable in Hollywood.

Another thing happened in '84—I met Hank O'Neal, who was editing a Berenice Abbott monograph at the time. When I saw her photographs, I became enamored by those she made in New York in the 30's. In particular, I liked the idea that you could look back in time to, say, July 16, 1936, Herald Square—it was like going back in a time machine. I may even be in that photograph, walking to Gimbel's with my mother through the crowds that I remember vividly. At sixty years old, I could suddenly see the world again as it was when I was ten. This revelation added to my awareness of the special powers of photography, which I was discovering in my own photos at that time.

Anyway, Hank finally introduced me to Abbott up in Maine one day, and I got along with her quite well. She had known Hart Crane, so I read her my poem *Howl*. She was impressed—she felt that it was real poetry in the same sense that Crane's *The Bridge* was real poetry to her. She treated me nicely and said something really interesting: "Don't be a shutterbug, young man," she said. "All these photographers with their 35 millimeter cameras go snap, snap, snap and can't get anything that way.... You have to set something up and use a large negative so that you can get the detail."

And I began to realize that if you want to achieve what Buddhists call "panoramic awareness" and at the same time what Blake would call "minute particulars," you would need a big format. So, I went out and bought myself a Rolleiflex as the first step to working up to bigger format cameras.

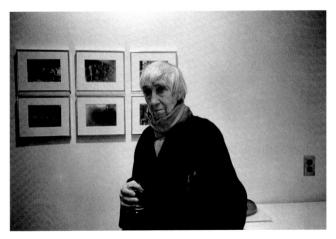

BERENICE ABBOTT AT 57TH STREET ART GALLERY RECEPTION PHOTO SHOW LEWIS HINE AND HER
PHOTOGRAPHS, 1985: "DON'T GET SO CLOSE OR YOU'LL GET A BULGING EYE OR CHEEK TOO BIG,
GO BACK A BIT SO YOU INCLUDE THE SPACE AROUND A PERSON," SHE TOLD ME AS I BACKED UP,
FOCUSED AND LISTENED.

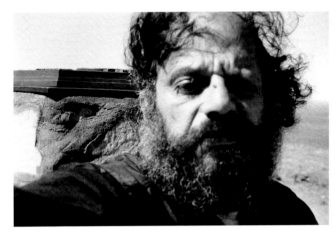

SELF-PORTRAIT AT ARM'S LENGTH, HIGH ON QUEENSLAND PSILOCYBIN MUSHROOMS, MIDDAY ON
TOP OF ULURU, AYERS ROCK, NEAR ALICE SPRINGS, CENTRAL AUSTRALIAN DESERT ABORIGINE
SACRED WATERPOROUS SANDSTONE MONOLITH, MARCH 24, 1972.

Contrary to what I thought earlier, I got to be good with the Rolleiflex pretty fast, as you can see from the picture "Harry Smith Pouring Milk." That was the first great picture I got with it, and is one of my favorites.

When I came back from visiting with Berenice Abbott, I said to Robert, "Well, I learned something from her." He replied, "Well,

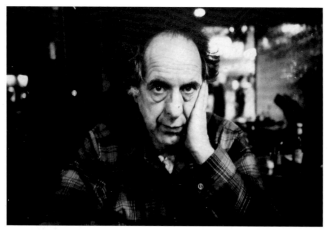

ROBERT FRANK, INQUISITIVE PRIVATE LOOK NOT UNKIND, PATIENT, "MAYBE I COULD SHOW YOU SOMETHING TOO." KIEV RESTAURANT 2ND AVENUE & 7TH STREET, MARCH 7, 1984.

maybe I can teach you a thing or two also." He had this very shy and funny smile, and the situation was funny. After all, we had known each other for almost thirty years and had even worked on movies together.

In 1958, I had worked on *Pull My Daisy* with him, and later had helped him with his own early film *Me & My Brother* (1964–66), which was about Peter (Orlovsky) and his brother Julius. When I came back from India he had wanted to make a film of *Kaddish*. I had no money at the time, so I went over to his house every other day and wrote a scene. For this he paid me ten dollars, and thus kept me in money for about two months while I was getting on my feet again.

But I never took him very seriously as an artist, because I didn't take photography very seriously. For many years we had a relationship just as friends or pals who had done things together. People kept telling me what a great photographer he was, so I began to look through his eyes with a practical purpose, as someone getting interested in photography. I realized how good he was at what he was doing—so much so that I even got a little scared of him.

Now, what exactly was it that he taught me? Well, there were always specific things—for instance, he advised me to include the hands of people in my pictures more often. But most importantly he looks at my pictures regularly. That is, when I have accumulated enough new prints I bring them over or he comes by and goes through them. I learn quite a lot from what he likes and from his suggestions for cropping or printing.

About two years ago, I showed Bob Dylan some photographs and he said, "Why don't you send me 200 prints without any identification, and I'll write captions for you." I went to Robert and said, "What shall I do, send him xeroxes, or should I send him small prints, because the big prints are expensive, and I may never see them again." Robert said, "Listen, you're a grown man, Dylan is a big genius, he asked you for 200 prints, you can do that. Give him what he asked for." I realized, "Yeah, why have I got this poverty attitude? I'm sixty years old and still afraid of doing something grown up like that?"

So I went through everything and lined up a couple of hundred pictures, and asked Robert to look at them. He came over and selected 140 that he liked. I had a way of seeing my pictures through his eyes, which proved quite helpful. It turned out we have a lot of similar inclinations. For instance, that picture of Neal and Natalie under the marquee is just like a Robert Frank picture, except that it was taken before I met him, or saw any of his work. It has that sense of the city street and of the poignancy of the unknown

lovers and the unknown people in the city streets and these amazing faces and you realize there's a vast life of their own....

This is why Robert and Kerouac got along so well. Both had an appreciation of Americana, and of the quotidian, everyday ordinary life in America. It's the notion of sacramental documentation, and of using the raw material of your own actual experience in your work, whether it fits accepted aesthetics or not. This theme is very clear in Kerouac's books—the motif of the sacredness of the world. This is the only time we're gonna be here, so it's not shit at all and it's not negligible. This is It. And if This is It, what could be more sacred? So you better appreciate it now, while it's here. You see, Kerouac was a Buddhist in the sense that he recognized not only the transitoriness of existence, but also its soullessness. Visible, say, in the ultimate look on people's faces. You find that in Robert Frank too, you know. There are certain faces in his photographs that are utterly alone, with just one hand clapping and no observer except him, by mistake. It's the appreciation of the poignancy of the

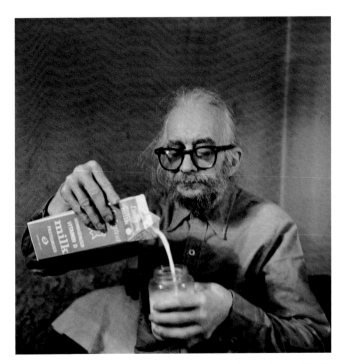

HARRY SMITH, HERMETIC PHILOSOPHER & ALCHEMIST TRANSFORMING MILK INTO MILK, HIS LAST DAYS' RESIDENCE AT HOTEL BRESLIN 28TH & BROADWAY MANHATTAN, JANUARY 12, 1985. HIS CLASSIC *HEAVEN AND EARTH* MOVIE PLAYS ANNUALLY AT THE FILMMAKER'S ARCHIVE.

passing moment that we all share, but arrive at by quite different roads, Jack by way of his Buddhist studies, Robert through his photography, and myself by way of a literary tradition that includes Whitman and William Carlos Williams—a "tradition" I started teaching recently as Photographic Poetics on snapshot poetics.

In January of 1988, Robert was invited to teach at the Camera Obscura School in Tel Aviv. He asked me if I wanted to come along and teach jointly with him—he photography and I poetry—so we developed a course called Photographic Poetics.

I traced the origins of the imagistic grounding of poetry that I had learned from Williams and its relation to the photographic practice. For instance, take Williams' poem *The Red Wheelbarrow*:

so much depends
upon

a red wheel
barrow

glazed with rain
water

beside the white
chickens.

It's just like a photo. I realized that Williams and the avant garde photographers of his day, people like Alfred Stieglitz and Charles Sheeler, were in close rapport with each other. They shared a common aesthetic of precise observation, and understood the importance of close attention to detail. Ezra Pound was writing on Phanopeia, which he described as "a casting of images upon the visual imagination"—you know, and in *How to Read*, he says there are three kinds of poetry: Melopeia, i. e. melodic; Logopeia, "the dance of the intellect among words"; and Phanopeia, i. e. imagistic, grounded in visual images.

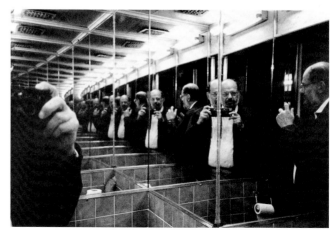

SELF-PORTRAIT, SUSHI BAR ON 2ND AVENUE NEW YORK, SEPTEMBER 24, 1985. I WENT TO THE TINY BATHROOM AND SAW MYSELF SEVERAL DOZEN TIMES MULTIPLIED, AGE 59.

And it was the phanopeic poem that I always cultivated as a result of my contact with Williams in the late '40s. In a sense, writing poems and taking pictures have been two discrete but very closely related activities. What I teach my poetry students in terms of snapshot poetics these days might also serve photography students, as you may see from the slogans I put down for my class at Naropa Institute in Boulder this summer:

Ordinary mind

includes eternal perceptions.

> Observe what's vivid.

Notice what you notice.

> Catch yourself thinking.

Vividness is self-selecting.

> First thought, best thought.

Subject is known by what she sees.

> Others can measure their vision by what we see.

Candor ends paranoia. ▶

plates

new york, autumn 1953

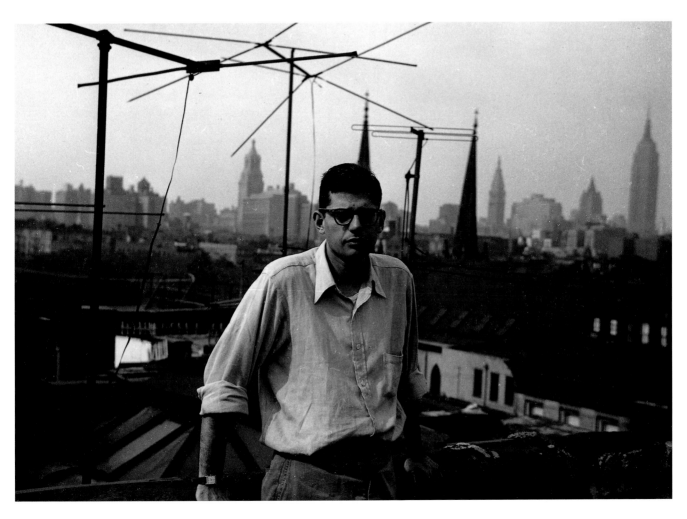

Portrait Snapshot by W.S. Burroughs, Kodak Retina 1953, my apartment roof E.7st, We edited Yage Letters. Allen Ginsberg

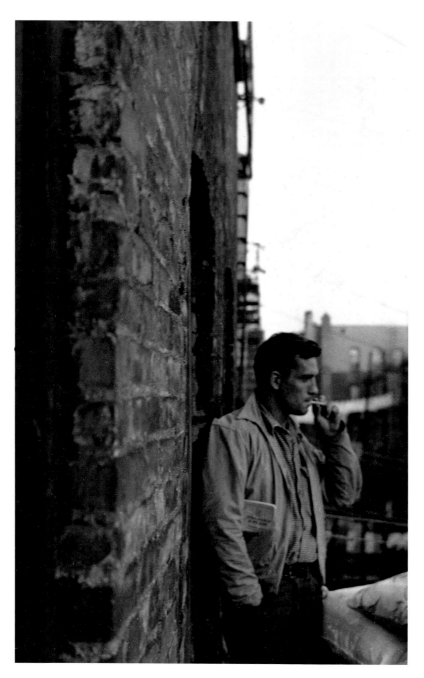

Heroic portrait of Jack Kerouac with R.R. Brakeman's
Manual in pocket, Fire-escape 206 East 7th Street N.Y.,
he'd completed on the Road, Visions of Cody & other books by
then, began adventures of the Subterraneans, Fall 1953 —
visiting W.S. Burroughs in my Lower East Side apartment.
 Allen Ginsberg

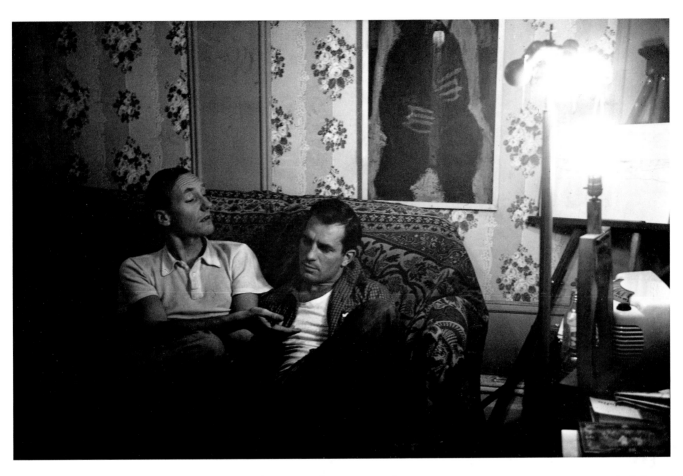

" But Jack I've told you before, if you continue going back to live with memere you'll be
wound tighter and tighter by her apron strings till you're an old man..." William Burroughs
acting the André Gidian sophisticate lecturing at country bumpkin Thomas Wolfian American
youth Jack Kerouac listening deadpan earnestly to "the most intelligent man in America". Fall
1953, my apartment 206 East 7th Street, Manhattan.
Allen Ginsberg

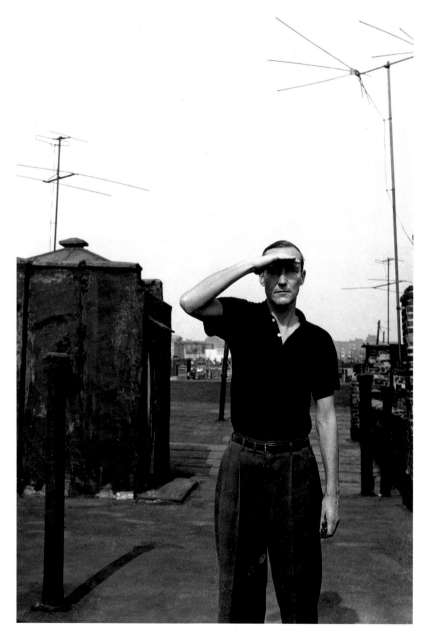

William Burroughs on roof of Apartment house
Lower East Side Fall 1953 New York When I lived,
we worked on editing his Yage letters, and mss. of
Queer, not published till 1985. Allen Ginsberg

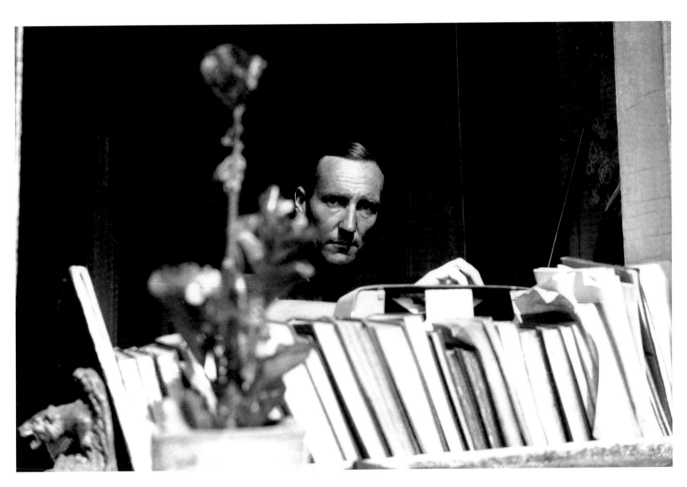

Bill Burroughs at bookshelf-window on fire escape 206 East 7th Street, Fall 1953. Drug store print this image used inside dust jacket rear-flap Olympia Press first edition Naked Lunch, late 1950's. He looks like Baudelaire. *Yage* & *Queer* mss. days. Allen Ginsberg

san francisco, 1955-1956

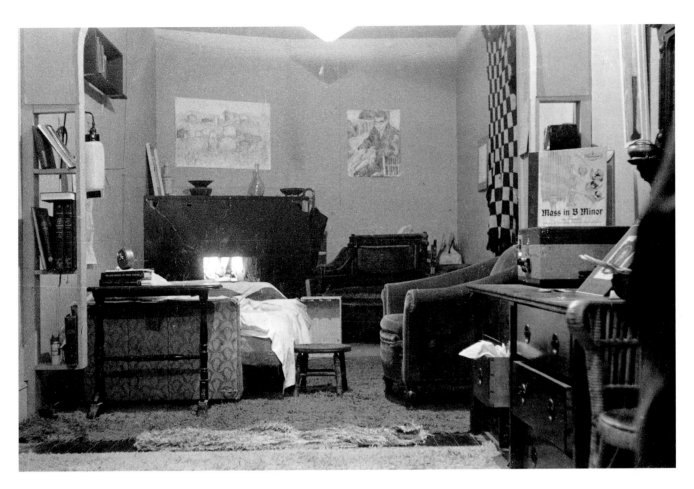

My room in apartment I shared with Peter Orlovsky (his room down the hall past the kitchen) at 1010 Montgomery Street San Francisco wherein I wrote poem "Howl", Spring 1955 or summer. "Blessed be the Muses/ for their descent/ dancing round my desk/ crowning my balding head/ with laurel." Robert LaVigne's portrait of me and Cézanne-like watercolor landscape pinned to wall, fireplace lit, Bollingen books & Bach, letters or essays of Ezra Pound, bed-table clock. Checkered blanket hung over alley window

Allen Ginsberg

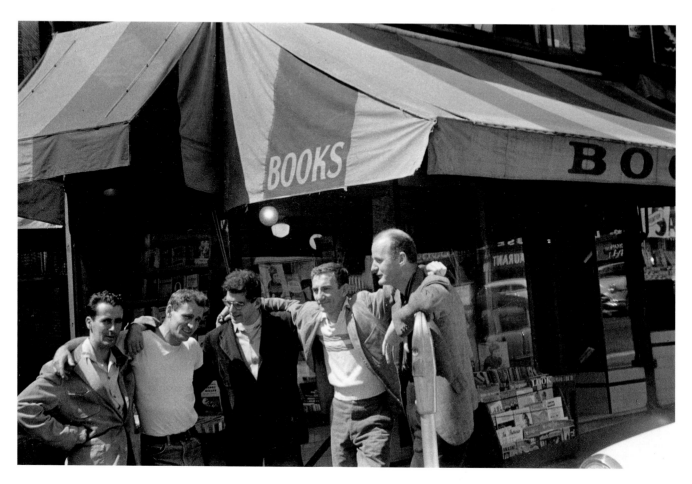

Bob Donlon (Rob Donnelly see J.K.'s <u>Desolation Angels</u>) Neal Cassady, Robert LaVigne painter, poet Lawrence Ferlinghetti (Allen Ginsberg in black Corderoy Jacket) in front of City Lights bookshop, North Beach Broadway & Columbus Avenue San Francisco late 1955. Howl Paperback wasn't printed yet, Neal looks good in t-shirt, we were just hanging around, Peter Orlovsky stepped back off curb camera in hand & snapped shot.

Allen Ginsberg

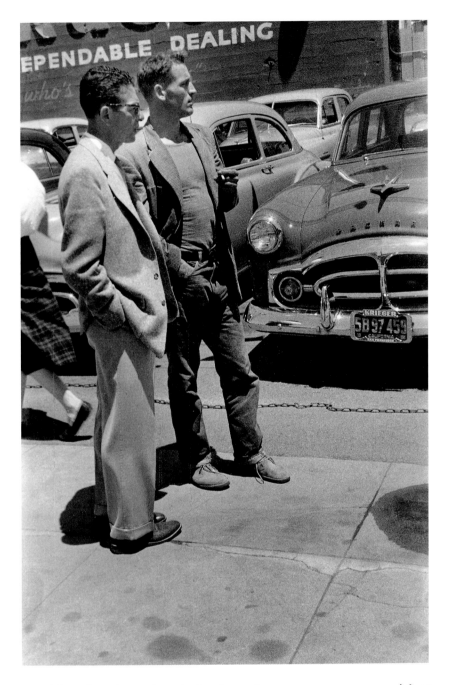

Neal Cassady with cigarette beside salesman surveying used Cars,
North Beach San Francisco 1955.
Allen Ginsberg

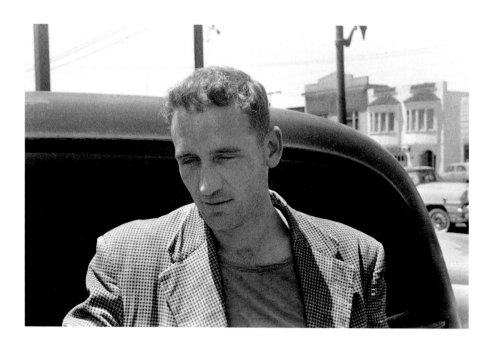

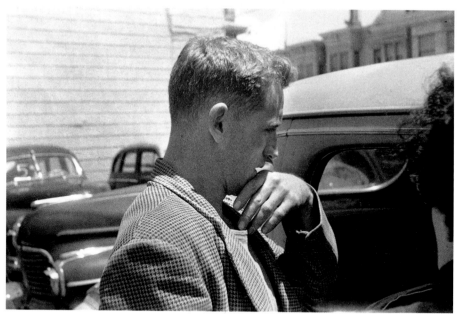

Neal Cassady young & handsome age 29 checking out cars in North Beach Used Car lot, San Francisco 1955. Bay area "Johnny Appleseed" of Pot, he'd gambled madly—disasterously! — at racetrack, working as Conductor on Southern Pacific R.R. had averted train crash years before as brakeman, breaking his ankle, collected insurance, bought his family a house in Los Gatos, visited me on Polk street, worked on his "First Third" Autobiographical manuscript.
 Allen Ginsberg

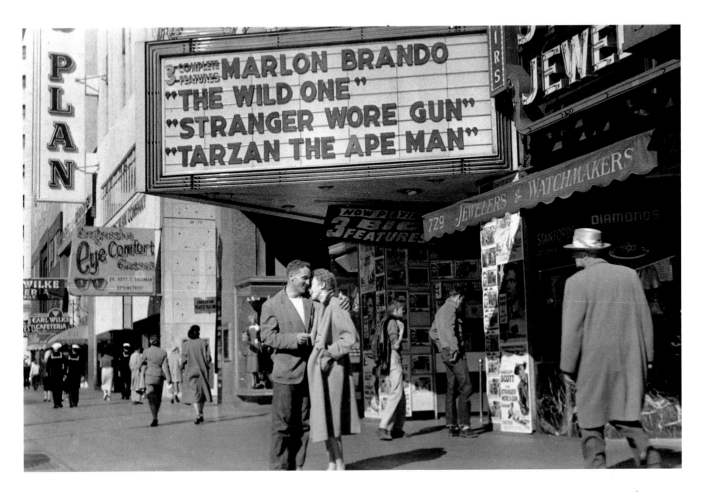

Neal Cassady and Natalie Jackson conscious of their rôles in Eternity, Market Street San Francisco 1955. As prototype of hero in Jack Kerouac's late 1940's saga On the Road (Dean Moriarty), Cassady's illuminated American automobile enthusiasm and erotic energy had already written his name in bright lights of our literary imagination before movies were made imitating his original charm. That's why we stopped under the marquee to fix the passing hand on the diamond watch. Allen Ginsberg

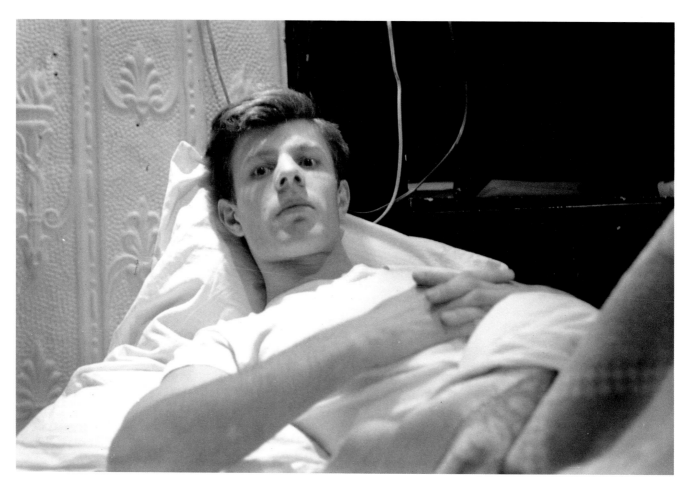

Peter orlovsky in bed, 1010 Montgomery Street, San Francisco (1984 !) 1955. Allen Ginsberg '84

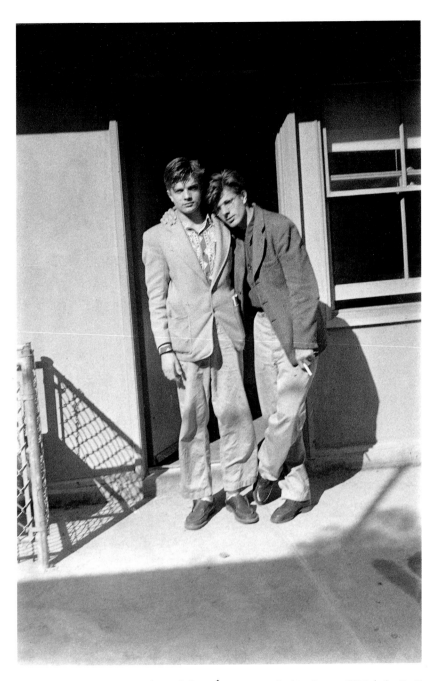

Lafcadio, 17, and Peter Orlovsky, 22, at their apartment door, 5 Turner Terrace, Probably Fall 1956 — new-built cheap rent veterans apartments on Potrero Hill dominated by a giant gastank overlooking south San Francisco bay. Lafcadio looking for a job was Cutting highschool, Peter worried. Allen Ginsberg

on the road, 1957-1964

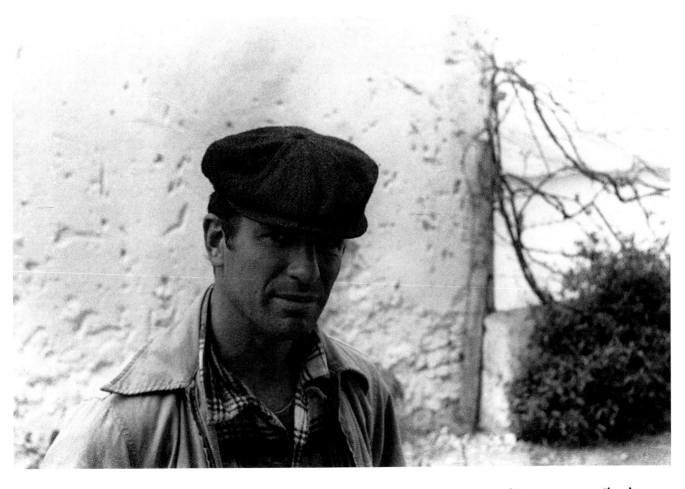

Jack Kerouac in Burroughs' garden Villa Mouneria Tanger 1957, he was retyping
"Interzone" section of <u>Naked Lunch</u> manuscript for Bill.
Allen Ginsberg

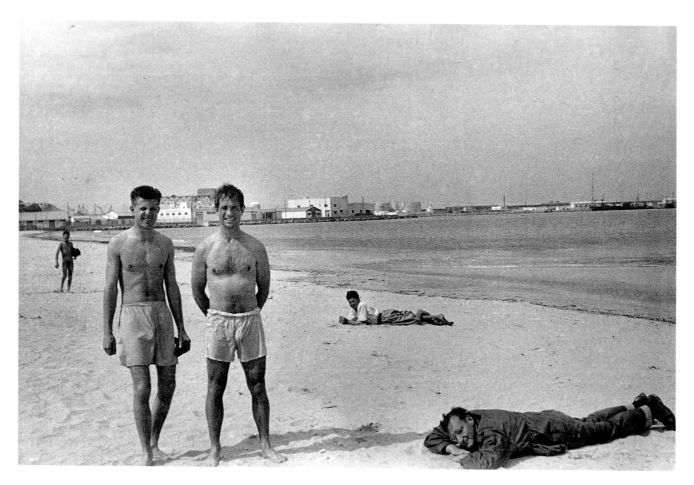

Peter Orlovsky and Jack Kerouac squinting in morning sunlight, William Burroughs prone observing in his olive green army jacket, Tanger Port docks behind them, & Customs house, where Peter & I landed on Yugoslavian Freighter — Kerouac left April 5, 1957, so this was in week before —

Allen Ginsberg

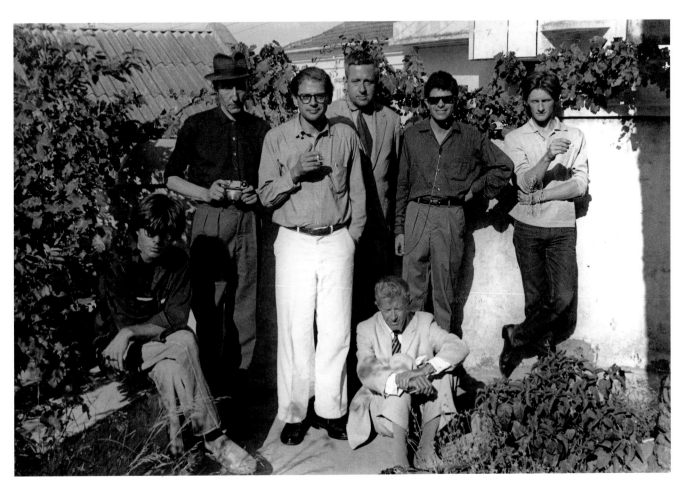

Peter Orlovsky legs crossed, William Burroughs with camera and hat for sun, myself white pants, Alan Ansen (W. H. Auden's & Burroughs' part time amanuensis), Gregory Corso sunglassed & minor'd, the late Ian Summerville (Burroughs' stroboscope-electronic sound assistant technician) on right, Paul Bowles seated squinting in bright noon light along Burroughs' doorway-garden wall, 1961 Tangier. My camera likely in Michael Portman's hands.

Allen Ginsberg

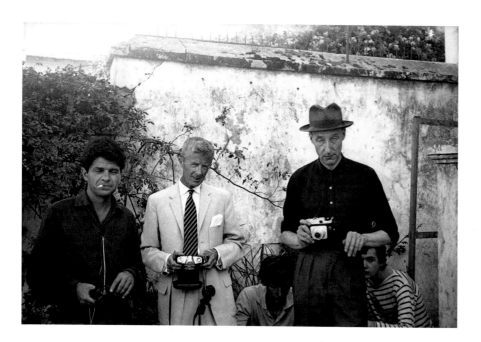

Gregory Corso, Paul Bowles, William Burroughs, behind him two dead boys: Ian Sommerville & Michael Portman, under the wall of Bill's Garden, Villa Mouneria Tanger 1961.
Allen Ginsberg

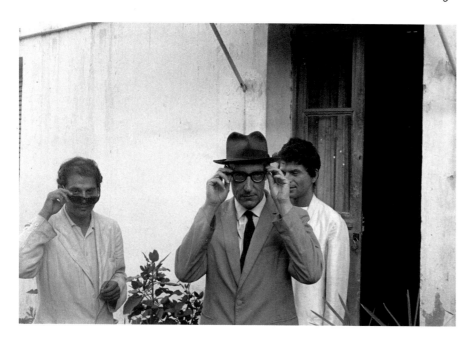

Allen Ginsberg, Wm. Burroughs, Gregory Corso, snapped by Peter Orlovsky with my Retina Kodak, Bill's doorway on to garden at Villa Mouneria, Tanger, 1961.
Allen Ginsberg

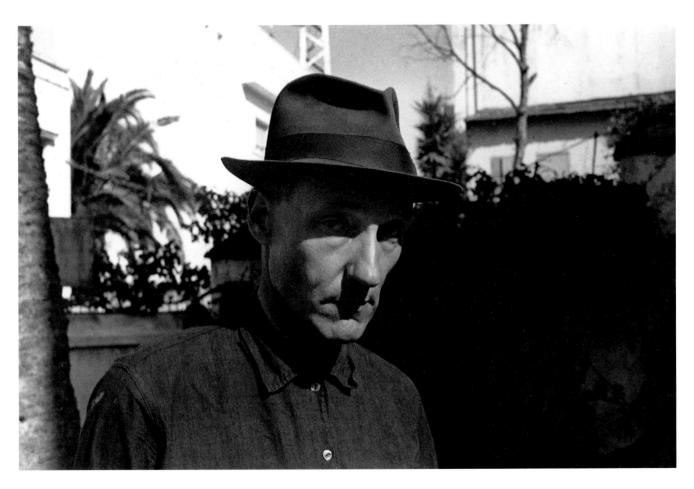

William S. Burroughs by garden wall outside his room Villa Mouneria Tanger Maroc 1961, slightly zonked looking suspiciously at me: "Who are you an Agent for Precisely?" He was then working out literary Cut-up montage techniques.

Allen Ginsberg

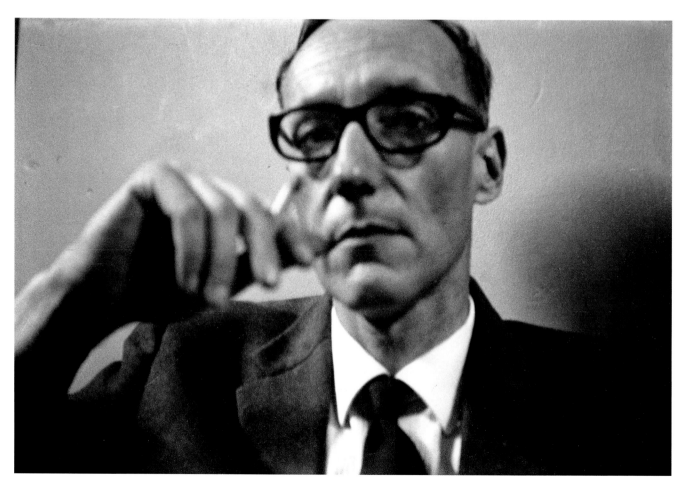

William Seward Burroughs Tanger Villa Mourneria 1961, his garden room, time of intense Cut-up prose experiments, <u>Nova Express</u> tracing Controllers of hypertechnologic planetary disaster "along the word lines" of their propaganda imagery back to the "image Bank" probably "a trust of giant insects in another galaxy" manipulating their human hosts to wreck the earth with radioactive Crap so another life form could move in and take over the territory.

Allen Ginsberg

Paris 1957 Gregory Corso, his attic 9 Rue Git-le-Coeur "Death" & "Clown" poems — Allen Ginsberg

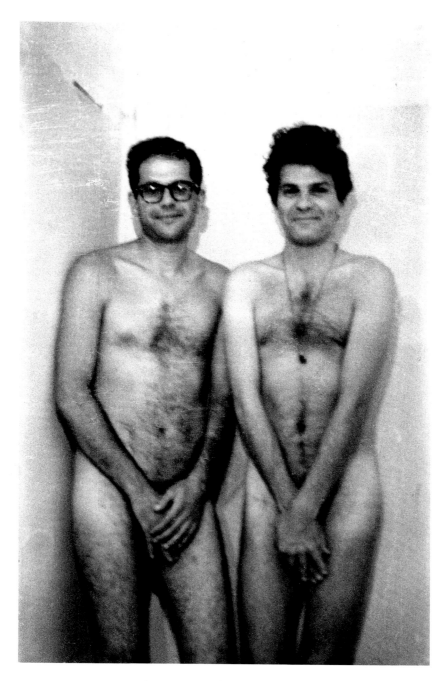

A Modest Portrait, Allen Ginsberg & Gregory Corso,
Tangiers 1961, camera in Peter Orlovsky's hand, our white-
washed room downstreet from Burroughs' Villa Mouneria.
 Allen Ginsberg

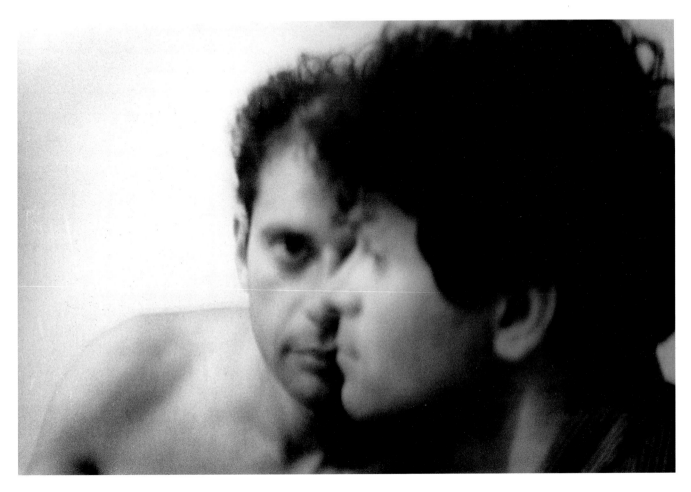

Gregory Corso and myself double portrait Poetry Siamese twins, my room Tanger, Maroc, 1961.
P. Orlovsky snapshot, my camera.
Allen Ginsberg

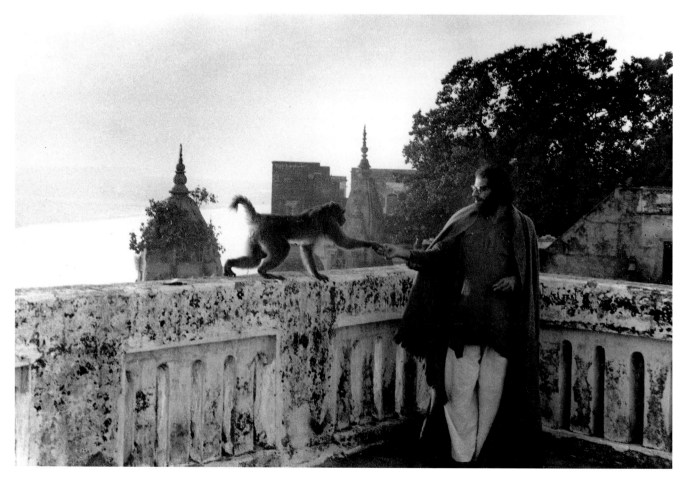

Morning rooftop visit, Brahmin's house on Dasasumedh Ghat, Benares India 1963, Ganges river, temple nath tops and further shore visible, we had a room overlooking Market vegetable meat piles on side and street alley way to left where bathers washed, other side below our balcony. Monkeys stole bananas from room where I stayed half year with Peter Orlovsky who snapped this moment with my Kodak Retina. See Indian Journals for more.

Allen Ginsberg

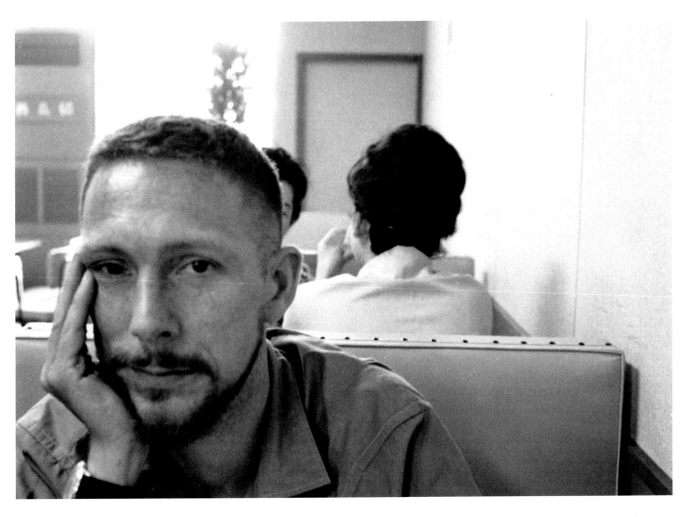

Gary Snyder then studying Zen Buddhism at Daitoku-ji precincts' First American Zen Institute, re-translating _Zen Dust_ a study of Koans, here at rest in Café probably on Juniken-doro street, Kita-ku section of Kyoto Japan, June 1963. Allen Ginsberg

Sea of Japan, travelling with Gary Snyder and wife Joanne Kyger, after year and half in India, on way home to Vancouver Poetry Conference, July 1963.
Allen Ginsberg

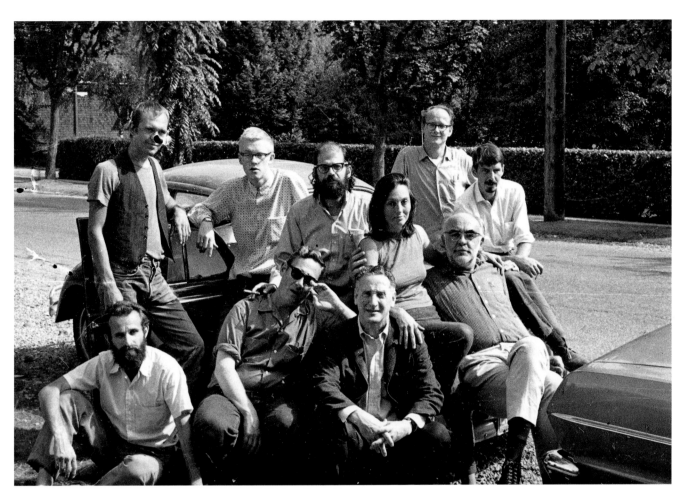

Jerry Heiserman (later Sufi "Hassan"), the late "Red" a poet, Allen Ginsberg, Bobbie Louise Hawkins Creeley, Warren Tallman, Robert Creeley above Charles Olson, left to right top rows; seated left Thomas Jackrell then student poet, Philip Whalen & Don Allen anthologist & Postmodern Poetics editor, last days of Vancouver Poetry Conference late July 1963, Car parked in front of host Professor Tallman's house — he'd sent me a ticket to come back from year and half in India for the assembly — which included Robert Duncan & Denise Levertov.
 Allen Ginsberg

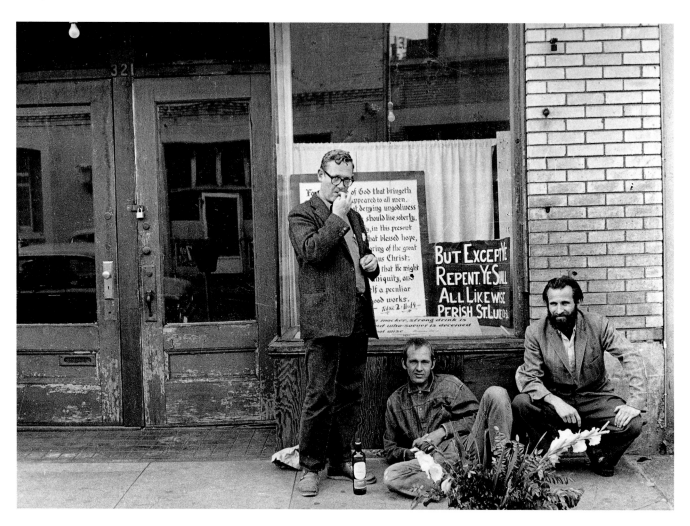

Philip Whalen, Jerry Heiserman & Thomas Jackrell (who'd written a poem about Campbell Soup Factory in Camden N.J.) sightseeing in Phil's old College town Portland Oregon on way back from Vancouver British Columbia Poetry Conference — Jackrell had an old van truck and drove us down the U.S. Northwest Coast to the Bay Area, July 1963, to San Francisco. Allen Ginsberg

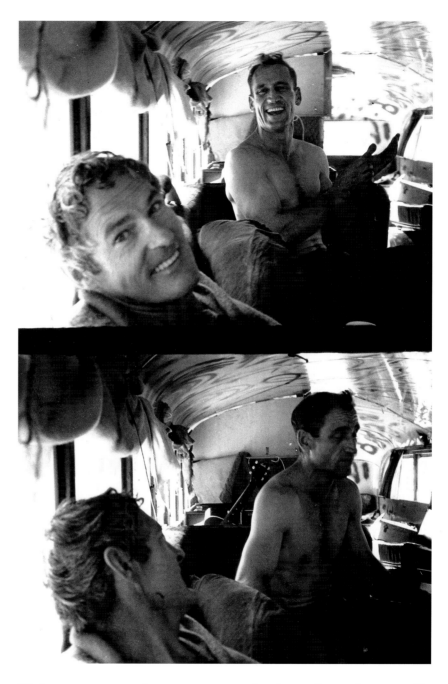

Timothy Leary visiting Neal Cassady who drove Prankster Bus to
Millbrook Psychedelic Research Center, Election year 1964. Allen Ginsberg

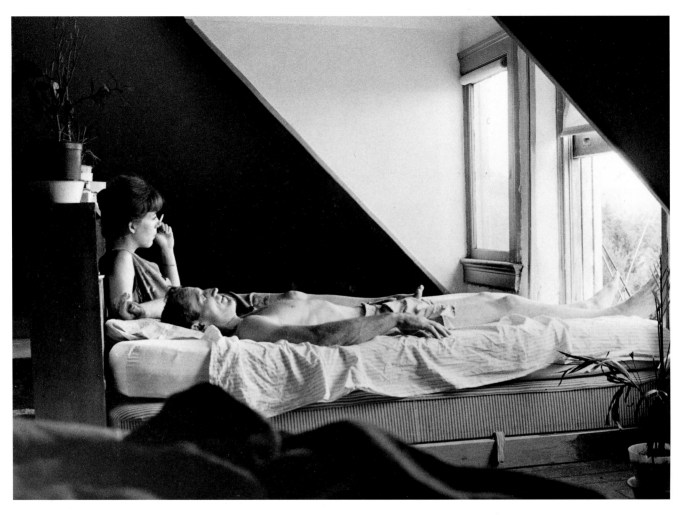

Neal Cassady & I went upstairs to attic at Millbrook estate Castalia Foundation
big house where Timothy Leary and friends were then experimenting with D.M.T. a
half-hour trip — here Neal resting eyes-closed with Millbrook lady friend in
charge of holding the vial of liquid psychedelica. I'd driven upstate from New
york city with Ken Kesey & merry Pranksters in their day-glo painted bus, recent-
ly arrived East Crosscountry from California, Neal at the wheel, Fall 1964
 Allen Ginsberg

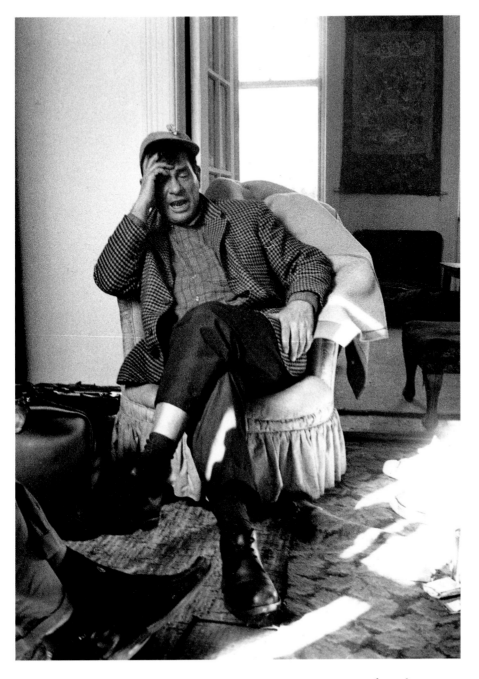

Jack Kerouac on visit to Manhattan, last time he stopped at
my apartment 704 East 5th Street Lower East Side, he then looked
like his father, corpulent red-faced W.C. Fields yawning with
mortal horror, eyes closed a moment on D.M.T. visions — I'd
brought some back from Millbrook where I'd recently been with
Neal Cassady in Kesey's bus, Pre-election 1964 Fall.
Allen Ginsberg

new york, 1984-1991

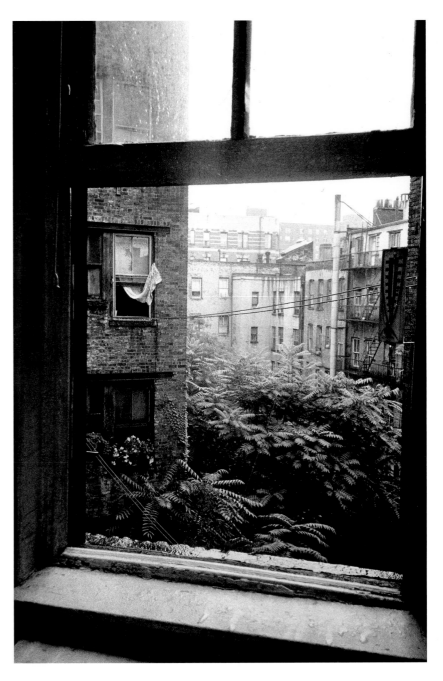

View out my kitchen window August 18, 1984, familiar Manhattan back-
yard, wet brick-walled Atlantis sea garden, ailanthus (stinkweed Tree of Heaven)
boughs waving in rainy breeze, Stuyvesant Town's apartment roof two blocks north
on 14th street - I focused on the raindrops on the clothesline. Allen Ginsberg

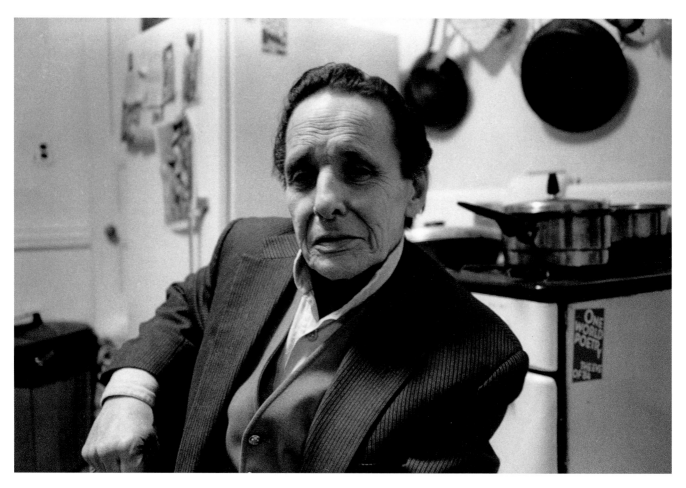

Herbert Huncke, New York, 1984, my kitchen, at the table, wry conversation — His new manuscript *Guilty of Everything* still to be edited.
 Allen Ginsberg

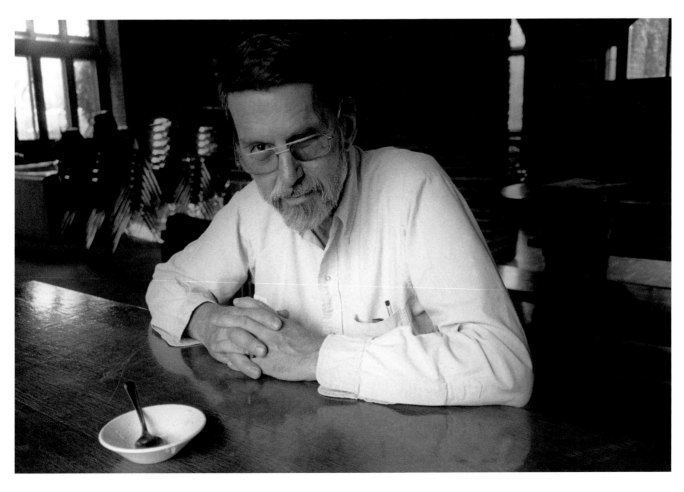

Robert Creeley one-eyed poet at Naropa Institute poetics commune house, summer session July 1984, he sat patient with me across supper table before his lecture, old friend.
 Allen Ginsberg

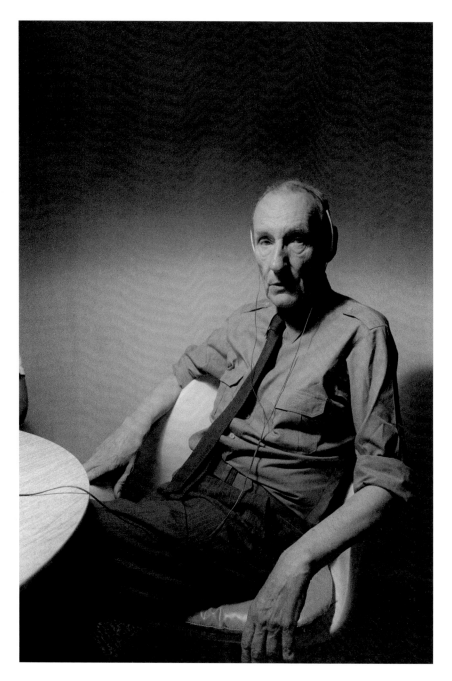

William Burroughs, Varsity Townhouse apartment, Naropa In-
stitute, Boulder, Colorado July, 1984, his annual visit to
our Buddhist College. Here listening to recent Poetry-Music
tapes I made, Probably White Shroud vocalized with String
Quartet. or Elvin Jones on Hum Bom sound Poem. Allen Ginsberg

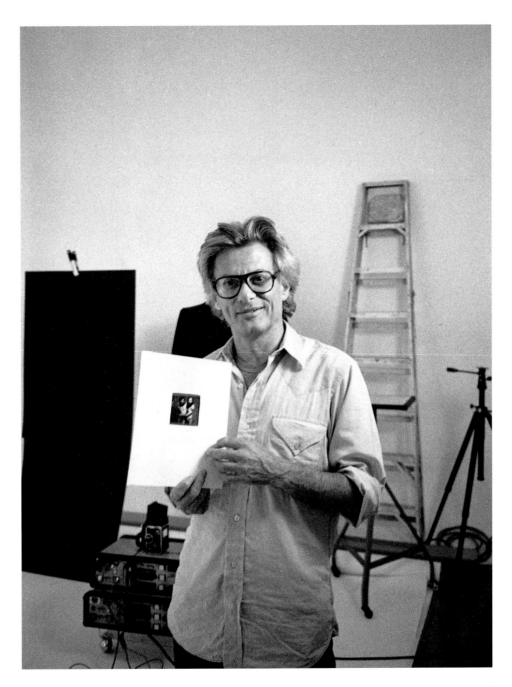

Richard Avedon, his studio September 1984. Twenty years earlier he'd taken classic portrait of Peter Orlovsky and me naked arms round each other's waists. He invited us back to pose the same, older. I brought my camera too. Allen Ginsberg

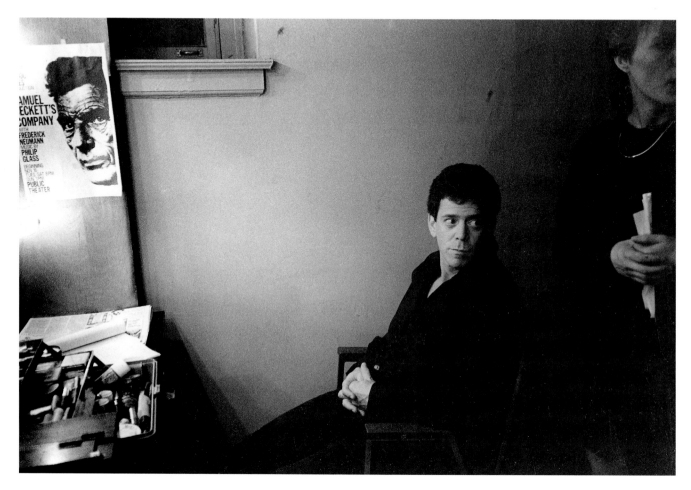

Lou Reed Poet Musician in Green Room at Makeup table, Public Theater on Laffag-
ette Street New York, September 1984, he Came invited by Rose Lesniak, above,
to be Master of Ceremonies at premiere of Video-Poetry-Music shorts by Anne
Waldman (oh oh Plutonium!) and myself (Father Death Blues) Allen Ginsberg

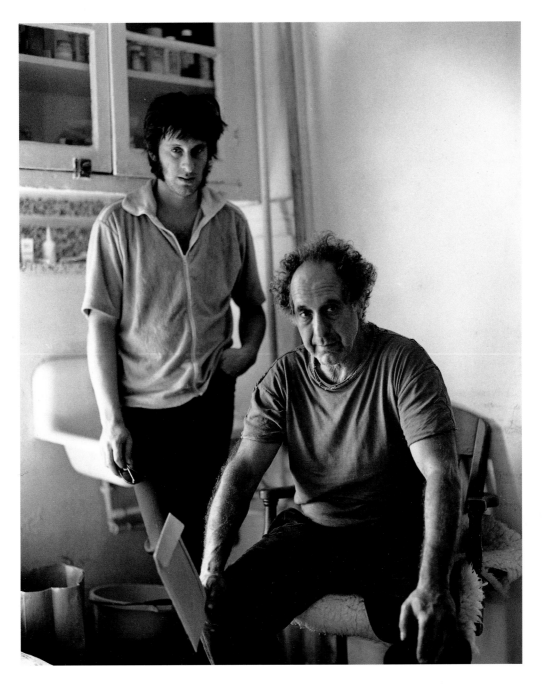

Robert and Pablo Frank visiting from Bronx State Hospital, my living room on East 12th Street New York, October 1984. Same noses. Allen Ginsberg

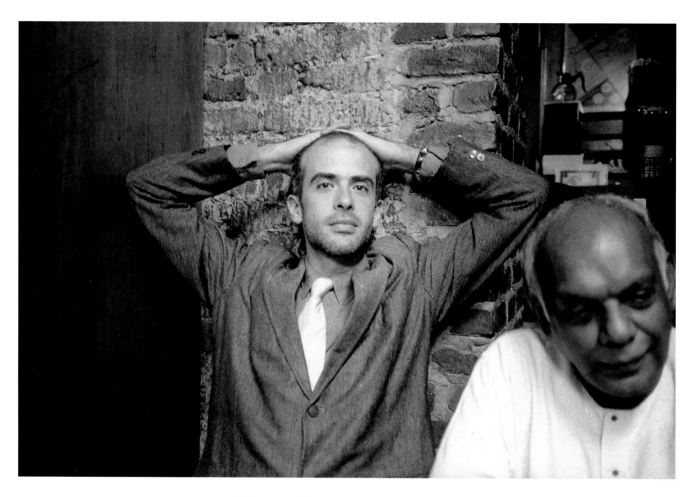

Francesco Clemente and Cz. Nachiappan (his printer host in Madras at Kalakshetra press) at Kiev Restaurant on Second Avenue & 7th Street october 1984, we wandered over to Ramana Maharshi center on 6'th street later on.
Allen Ginsberg

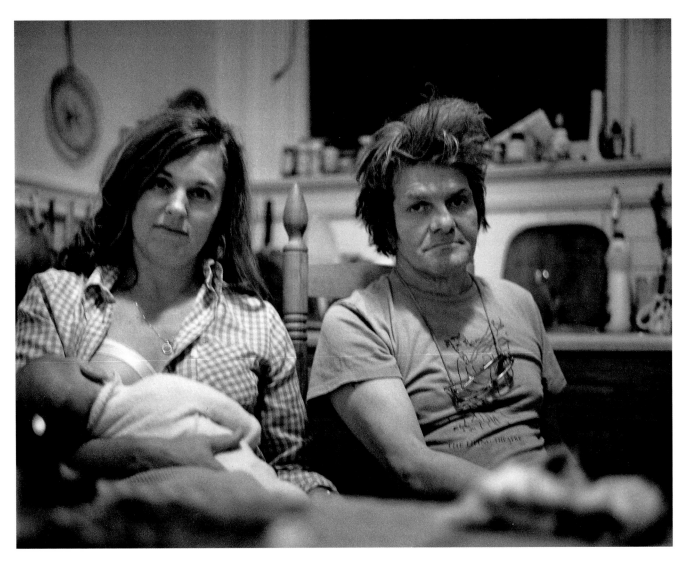

Kay MacDonough, their son Nile, and father Gregory Corso at home, Telegraph Hill San Francisco October 1984 as prophecied in his Poem Marriage (1959): "... and she gives birth to a child and I am sleepless, worn/up for nights, head bowed against a quiet window—/the Past behind me ..." Allen Ginsberg

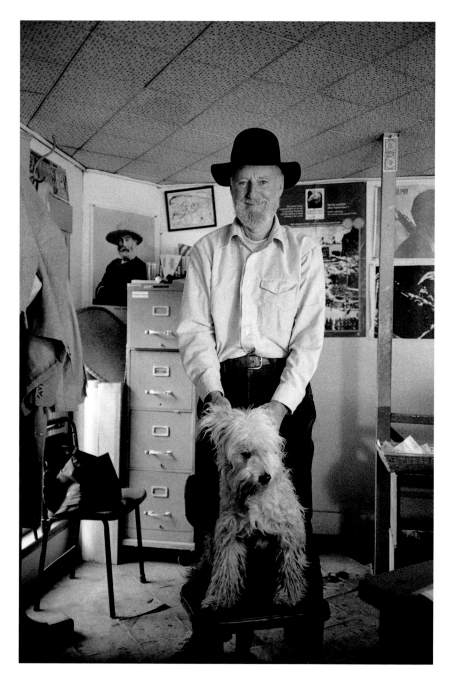

Lawrence Ferlinghetti in his office with Pooch, Whitman Photo, files, coat racks, book bags, posters, at City Lights up on balcony, B'way and Columbus Avenues, San Francisco, October 1984. Allen Ginsberg

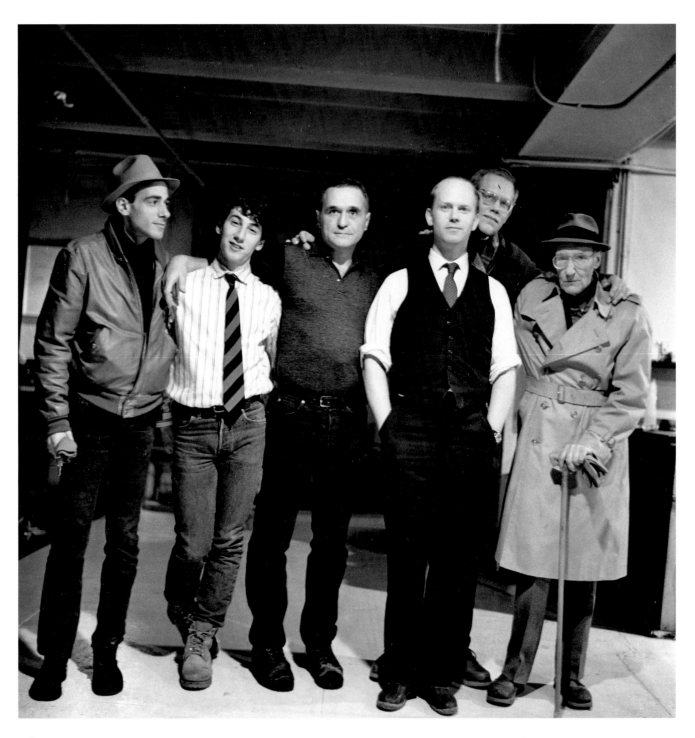

The Burroughs mob; Stewart Meyer (Lotus crew memoirist) driver, Ira Silverberg, John Giorno poet, Andrew Wylie agent, James Grauerholz Bill's Secretary and Ira's boyfriend, and shrunken Godfather Wm. S. Burroughs, in his "Bunker" loft 222 Bowery New York January 19, 1985.

Allen Ginsberg

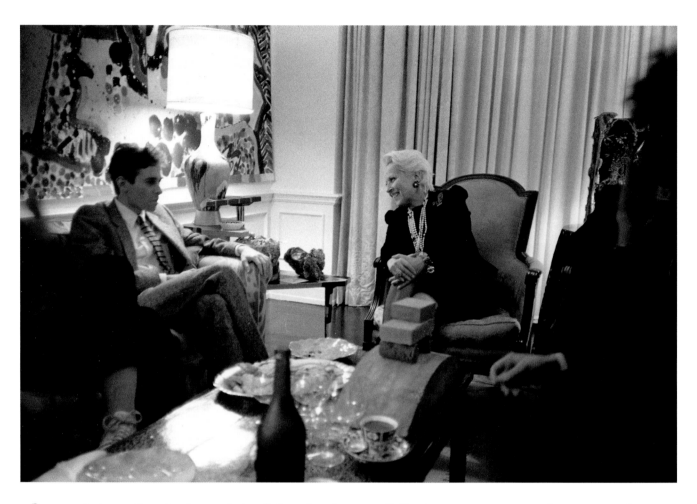

Raymond Foye, Curator of my first Photography show, and Holly Solomon, private dinner party at her apartment January 1985. I was still excited, snapping pictures that month. Allen Ginsberg This print for Raymond with love, and thankfulness.
9/17/85

Kathy Acker in Green Room, Detroit Institute of Arts,
one night February 1985 we read together with Diane
Di Prima — she writes violent-sexed feminist narratives,
Parody or imaginative love-torture novels, lives in London,
first published chapters of books as pamphlets & found in
the mail from lower East Side New York — Allen Ginsberg

*Dick McBride, Shigeyoshi Murao both City Lights Bookshop Pioneers, &
Poet Jack Micheline, thru doorway of Trieste Café, San Francisco's
North Beach, my reflection in glass with weather jacket back from
Shanghai a few months earlier, March 16, 1985. Allen Ginsberg*

Front of Trieste Café Grant & Vallejo Street San Francisco Calif-
ornia — on corner Neeli Cherkovski & his friend Dr. Jesse Cabrera,
Gregory Corso holding son Nile, Kay MacDonough behind them,
March 16, 1985 — street painter foreground daubing the Café,
morning haunt of North Beach poets & bohemians to this day.
Allen Ginsberg
11/23/88

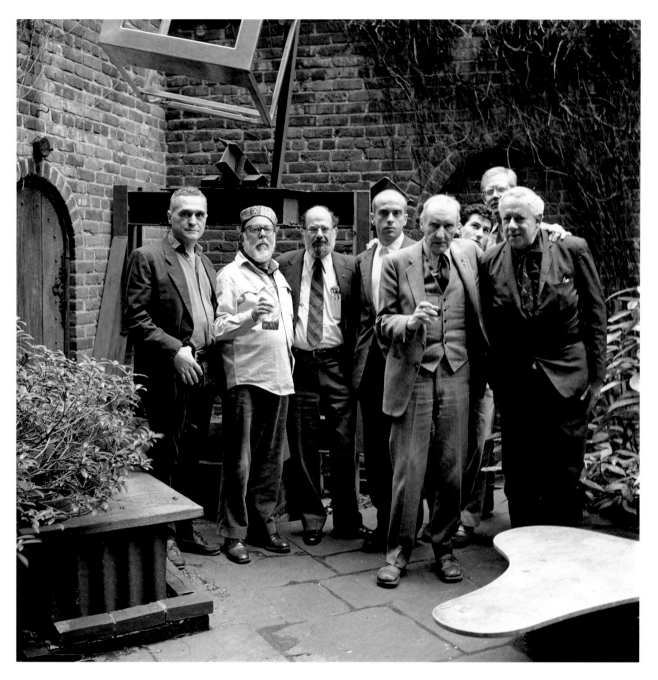

Gathering at Henry Geldzahler's house backyard 9th Street New York the afternoon before Francesco Clemente's double vernissage Mary Boone/Leo Castelli Galleries March 30, 1985: John Giorno, Geldzahler, Allen Ginsberg, Clemente, William Burroughs, Alan Ansen visiting from Athens — Jim Grauerholz & his boy friend at the time Ira Silverberg peeking over Burroughs' shoulder (J.G. Burroughs' secretary.) Camera in Raymond Foye's hands.

Allen Ginsberg

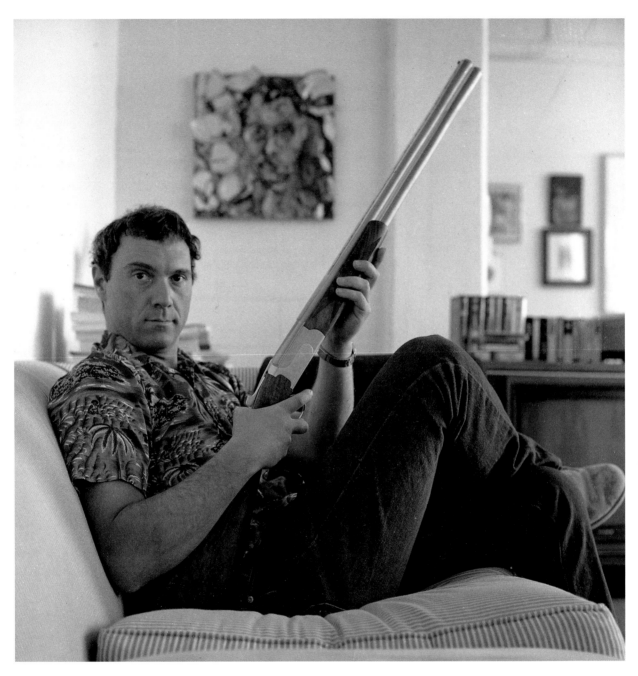

Sandro Chia had been shooting in Rhinebeck with William Burroughs
a week before — here with his shotgun in 's studio-apartment New York
April, 1985 — Julian Schnabel's portrait of him on the wall — I liked the
magic romantic surreal tricks in his canvases that year, much like G.
Corso's poetry he illustrated in a rare large book. Big guy, big atelier —
those painters make a lot of money. A Rhinebeck estate! — Allen Ginsberg

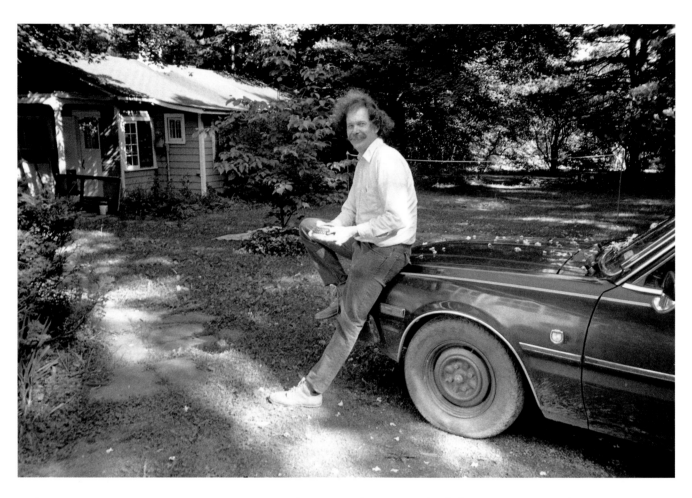

Ed Sanders in his leafy front yard, Woodstock New York June 30, 1985 trying to put
hubcap back on his tire, I was on way to visit Karmapa Monastic Center, top of nearby mount-
ain, he was working with revived Fugs Poetry Rock Band, inventing "electronic lyre" and
tuning Sappho's Mixolydian verse.
 Allen Ginsberg

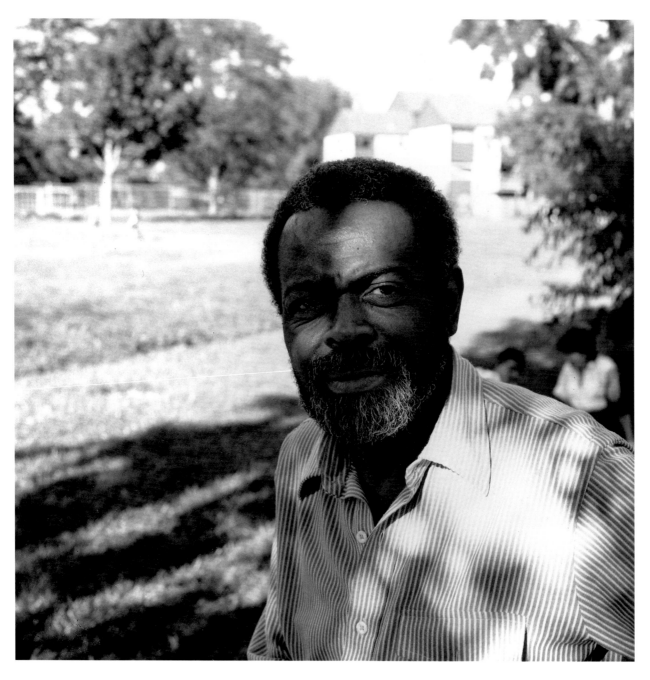

Poet Amiri Baraka (Leroi Jones) at picnic outside Naropa
Institute (first accredited Buddhist College in Western World). A
Marxist, old friend from late 1950's Beat Poetry days New York,
he taught Black literature with us at "Jack Kerouac School of
Disembodied Poetics," tho a little suspicious of our meditation
Practice. August 1985.
 Allen Ginsberg

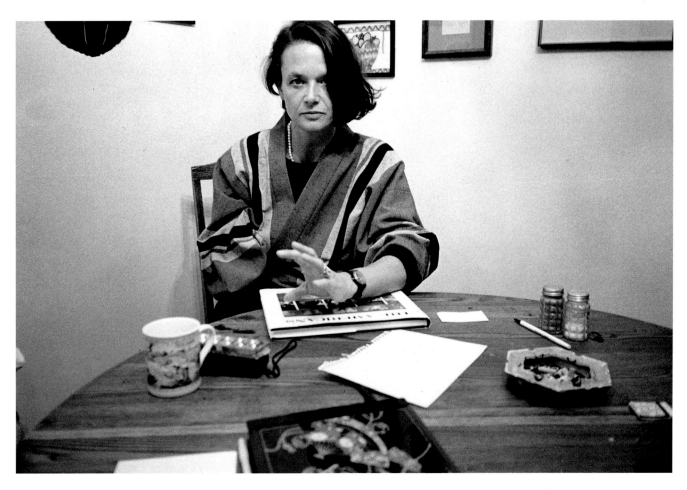

Anne Waldman, orator Poet directress of Naropa Institute Poetics School at Jane Faigao's table, August 15, 1985. Robert Frank's <u>The Americans</u> under her wrist. Allen Ginsberg

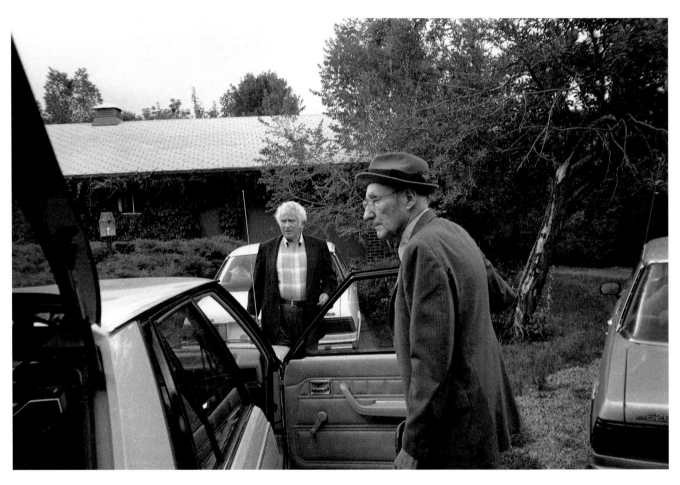

Norman Mailer joined William Burroughs at Naropa Institute Summer 1985
to spend a week be end with Symposium on "The Soul: Is there one, what Is It,
Ce what's Happening To It" here leaving John Steinbeck III's backyard after visit.
Allen Ginsberg

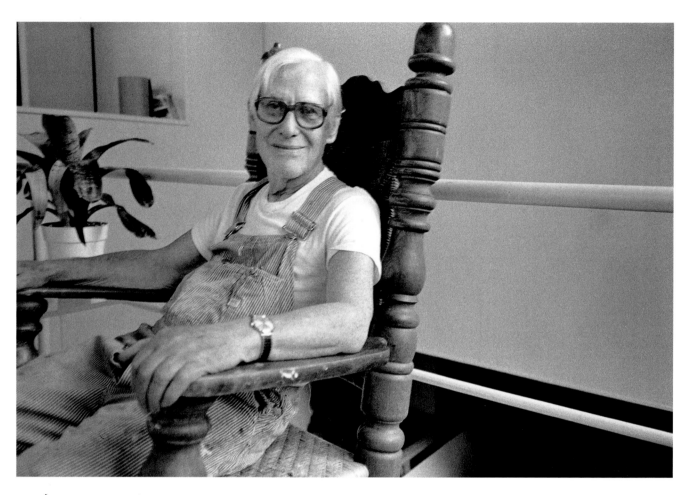

Willem de Kooning in his studio Springs, L.I. September 13, 1985, I visited with my step-mother Edith, his fly was unbuttoned, he said of his canvasses, "I'm just a sign-painter." Allen Ginsberg

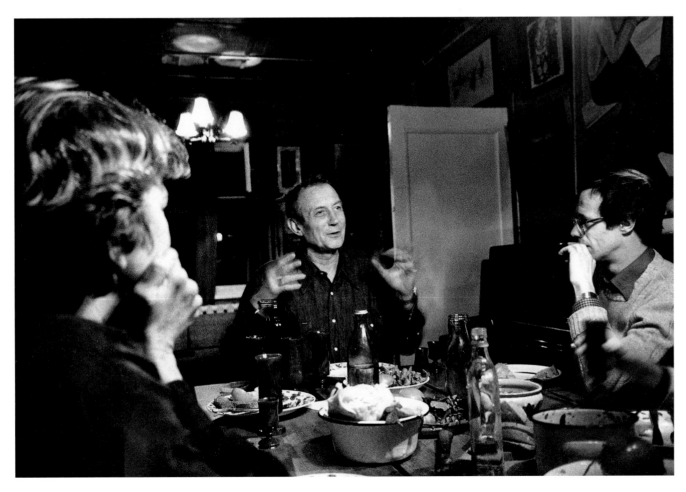

Yevgeny Yevtuchenko, his night suppertable loaded with Cabbage soup, vodka, bread, pickled mushrooms, Conversation in his dascha, peredelkino an hour's drive out of Moscow, December 1985. My interpreter with glasses, listening, had said (as Russian yuppie journalist) "I know what buttons to push, who to telephone, 'I can get along with this system,' in the car on way out. Allen Ginsberg

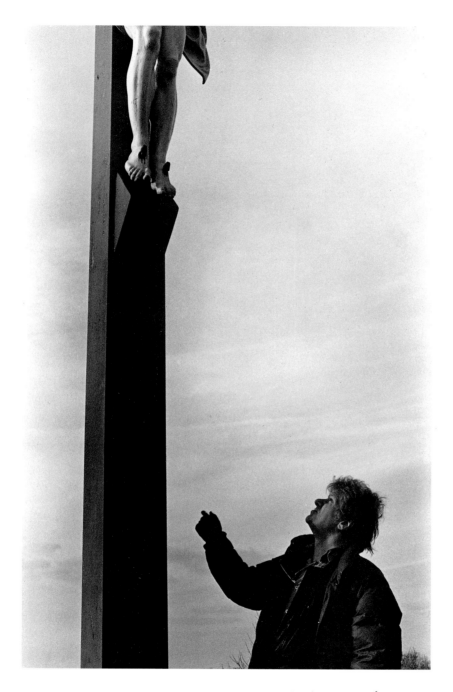

Gregory Corso visiting Cross on top the Grotto Kerouac immortalized in Book 4 Chapter 1, Dr. Sax — here memère knelt and prayed too. Lowell Massachusets, March 17, 1986. Allen Ginsberg

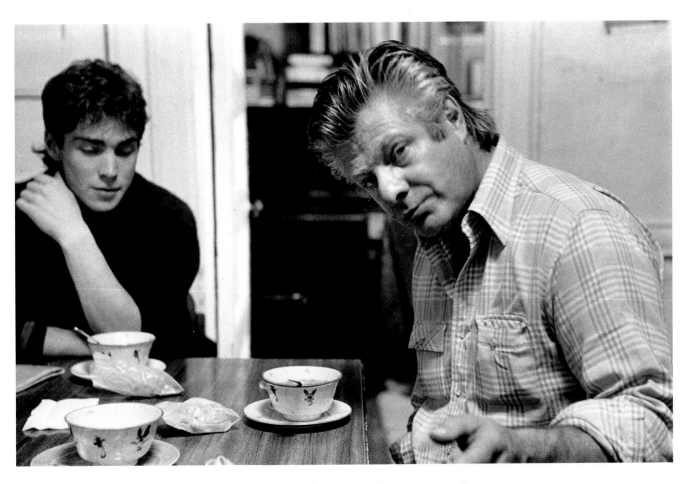

Peter Orlovsky eating Chinese take-out supper with Peter Hale, young ex-Naropa now Classics student, our ap-
artment kitchen Manhattan December 2, 1986.
Allen Ginsberg

Philip Whalen, Sensei, staying over in my bedroom East 12 Street,
visiting New York from Santa Fé Zen Center, he'd read Poetry &
lectured in my Brooklyn College Class "Literary History of the Beat Gen-
eration" a week before. March 16, 1987.
 Allen Ginsberg

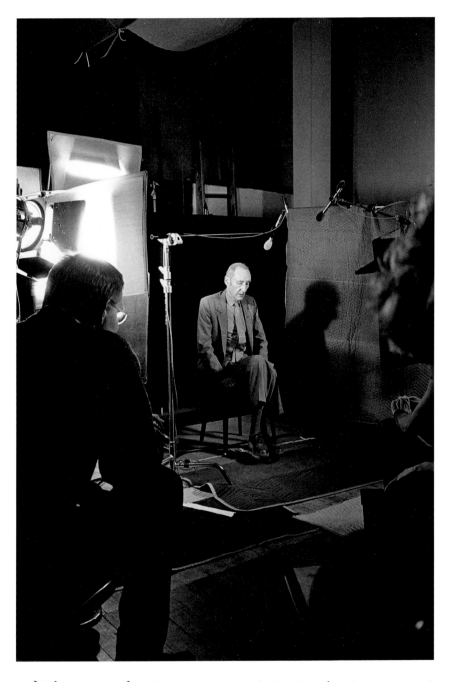

William Burroughs, film interview Soho New York December 21,
1986, secretary Jim Grauerholz leaning forward observing dis-
cussion of world of 1940's, memoirs.
 Allen Ginsberg

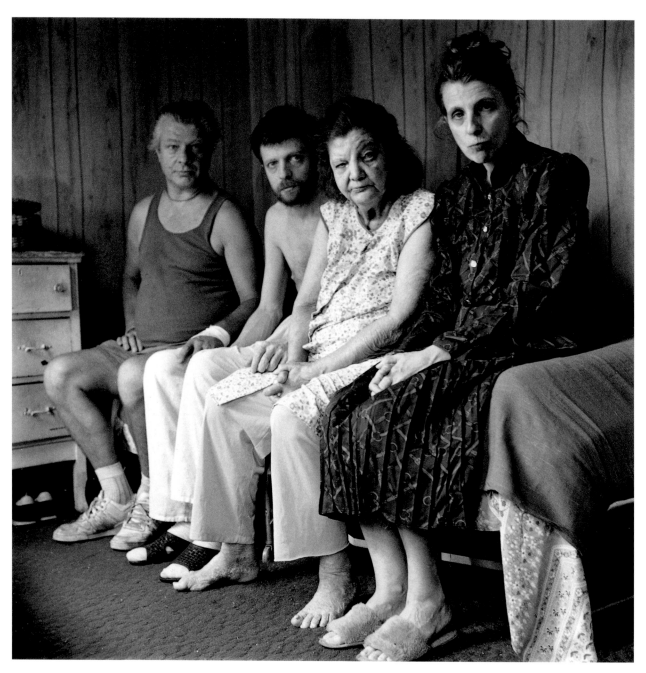

Peter Orlovsky b. 1933 visiting his family — Lafcadio age 47 had lived with us in San Francisco N.Y. 1955-61 & later intermittent years; mother Kate Orlovsky age 78 totally deaf after botched mastoid operation N.Y. Eye & Ear Hospital circa 1930's; Laff's twin sister Marie who'd lived with me & Peter O. in Lower East Side 1959 while she attended baby nurse school in Jersey — but quit jobs soon after, angry at hearing voices' filthy gossip behind her back. Center Moriches Long Island, their second floor flat on lonely road, they need taxi to supermarket shopping miles away with S.S.I. Checks. July 26, '19 87 visit. Allen Ginsberg

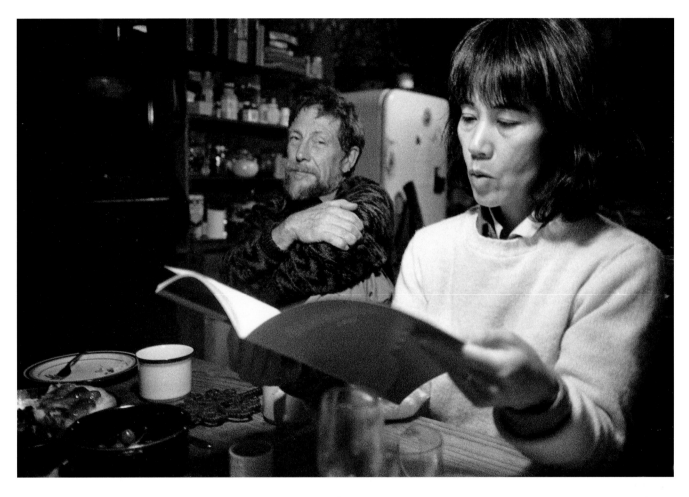

Gary and Masa Snyder after supper in their kitchen "Kitkitdizze" on San Juan Ridge, a Japanese style farm house 3000 feet up in park-like oak and Ponderosa pinewoods on western slope of Sierras near Nevada City California, ~~March~~ May 30, 1988. Allen Ginsberg

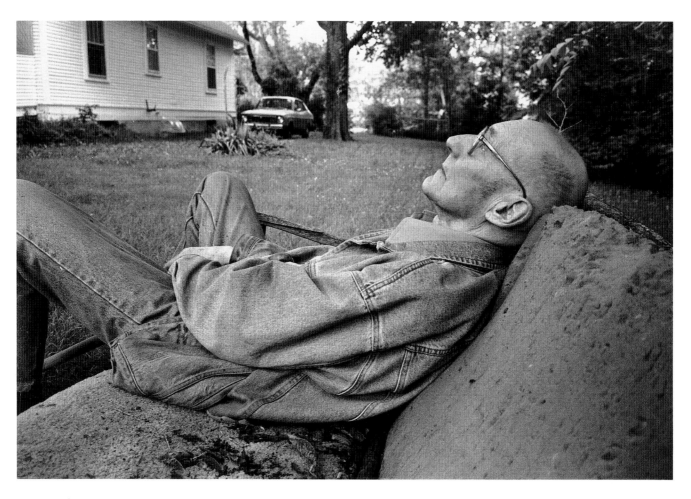

William Seward Burroughs relaxing on old brokendown foam-rubber couch in side-yard of his house, looking up through tree tops into the sky, Lawrence, Kansas May 28, 1991.
Allen Ginsberg

picture
captions

new york, autumn 1953

The months between August and December of 1953 were the last extended period that the original Beat writers were to spend together in New York, a period captured in Kerouac's *The Subterraneans*. Their central meeting place was Ginsberg's apartment at 206 E. 7th Street on the Lower East Side. Ginsberg was earning his living as a copyboy at the *New York World Telegram*, and planned to set off in December on an extended trip to Mexico. Burroughs was staying with Ginsberg after his sojourn in Central America, before making his way to Tangier, where he intended to make his new home. Burroughs' stopover in New York gave him a chance to work with Ginsberg on the text of the letters which he had sent Ginsberg from Central America, describing his search for *yage*, a hallucinogenic drug. Their correspondence was published by City Lights in 1963 as *The Yage Letters*.

Also back in New York after a long absence was Jack Kerouac, who had just spent a disappointing time with Neal Cassady and his wife, Carolyn, in San Francisco training to become a brakeman on the Southern Pacific Railroad. Kerouac had moved back in with his mother in Richmond Hill, Queens, and was traveling into Manhattan every weekend to meet his friends and accompany them to bars in the Village. He had already completed *On the Road, Visions of Cody*, and *Maggie Cassidy*, but only his first novel, *The Town and the City* (1950), had yet seen print.

PAGE 19. Portrait snapshot by W. S. Burroughs, Kodak Retina 1953, my apartment roof E. 7 St., we edited Yage Letters.

PAGE 20. Heroic portrait of Jack Kerouac with R.R. Brakeman's manual in pocket, fire-escape 206 East 7th Street N.Y., he'd completed On the Road, Visions of Cody & other books by then, began adventures of The Subterraneans, Fall 1953—visiting W. S. Burroughs in my Lower East Side apartment.

PAGE 21. "But Jack I've told you before, if you continue going back to live with memère you'll be wound tighter and tighter by her apron strings till you're an old man..." William Burroughs acting the André Gidian sophisticate lecturing at country bumpkin Thomas Wolfian American youth Jack Kerouac listening deadpan earnestly to "the most intelligent man in America." Fall 1953, my apartment 206 East 7th Street, Manhattan.

PAGE 22. William Burroughs on roof of apartment house Lower East Side Fall 1953 New York where I lived, we worked on editing his Yage Letters, and mss. of Queer, not published till 1985.

PAGE 23. Bill Burroughs at bookshelf-window on fire escape 206 East 7th Street, Fall 1953. Drugstore print this visage used inside dust-jacket rear flap Olympia Press first edition Naked Lunch, late 1950's. He looks like Baudelaire. Yage & Queer mss. days.

san francisco 1955-1956

After Ginsberg's trip to Mexico, which lasted the whole of the first half of 1954, he decided to spend some time in San Jose. Ginsberg hoped that physical proximity to Neal Cassady would give their relationship a chance to deepen, but Carolyn became jealous. An awkward situation; Ginsberg moved to San Francisco and saw Neal frequently there.

At the end of 1954, Ginsberg met his longtime companion, Peter Orlovsky. They soon moved in together, and—with the blessings of his therapist—Ginsberg quit his job in market research to devote himself exclusively to writing poetry. Not long after, toward the end of the spring of 1955, Ginsberg composed his longest, most successful poem to that point: *Howl*. (For a long time Ginsberg believed that Kerouac had suggested the title for the poem in a letter, but Ginsberg's own examination of an early draft in 1980 showed that he had titled the poem himself and forgotten.)

While working on *Howl*, Ginsberg had gotten to know a large number of other young poets in San Francisco. From this nascent community emerged the idea of a joint public reading that would introduce them all to a wider public. The reading would take place at the Six Gallery. In addition to Ginsberg, the other names on the postcards sent out advertising this "charming event" were Philip Lamantia, Michael McClure, Gary Snyder, and Philip Whalen. The reading, on the 13th of October, 1955, proved an enormous success. The next day Lawrence Ferlinghetti expressed his eagerness to publish *Howl* with a note to Ginsberg paraphrasing Emerson to Whitman—"I greet you at the beginning of a great career. When do I get the manuscript?"—and arts pages as far away as New York hailed a sudden renaissance of poetry in San Francisco.

PAGE 25. My room in apartment I shared with Peter Orlovsky (his room down the hall past the kitchen) at 1010 Montgomery Street, San Francisco wherein I wrote poem Howl, Spring 1955 or summer. "Blessed be the Muses/for their descent/dancing round my desk/crowding my balding head/with laurel." Robert La Vigne's portrait of me and Cézanne-like watercolor landscape pinned to wall, fireplace lit, Bollingen books & Bach, letters or essays of Ezra Pound, bed-table clock. Checkered blanket hung over alley window.

PAGE 26. Bob Donlin (Rob Donnelly see J. K.'s Desolation Angels) Neal Cassady, Robert La Vigne painter, poet Lawrence Ferlinghetti (Allen Ginsberg in black corduroy jacket) in front of City Lights bookshop, North Beach Broadway & Columbus Avenue San Francisco late 1955. Howl paperback wasn't printed yet, Neal looks good in t-shirt, we were just hanging around, Peter Orlovsky stepped back off curb camera in hand & snapped shot.

PAGE 27. Neal Cassady with cigarette beside salesman surveying used cars, North Beach San Francisco 1955.

PAGE 28. Neal Cassady young & handsome age 29 checking out cars in North Beach used car lot, San Francisco 1955. Bay Area "Johnny Appleseed" of pot, he'd gambled madly—disastrously!—at racetrack, working as conductor on Southern Pacific R.R. had averted train crash years before as brakeman, breaking his ankle, collected insurance, bought his family a house in Los Gatos, visited me on Polk Street, worked on his "First Third" autobiographical manuscript.

PAGE 29. Neal Cassady and Natalie Jackson conscious of their roles in Eternity, Market Street San Francisco 1955. As prototype of hero in Jack Kerouac's late 1940's saga On the Road (Dean Moriarty), Cassady's illuminated American automobile enthusiasm and erotic energy had already written his name in bright lights of our literary imagination before movies were made imitating his original charm. That's why we stopped under the marquee to fix the passing hand on the diamond watch.

PAGE 30. Peter Orlovsky in bed, 1010 Montgomery St., San Francisco (1984!) 1955.

PAGE 31. Lafcadio, 17, and Peter Orlovsky, 22, at their apartment door, 5 Turner Terrace, probably Fall 1956—new-built cheap-rent veterans apartments on Potrero Hill dominated by a giant gastank overlooking south San Francisco bay. Lafcadio looking for a job was cutting high school, Peter worried.

on the road 1957-1964

These photographs show Ginsberg and his friends during the years when public interest in their work was at its height. Something they would never have imagined possible had suddenly come about. Their books appeared in quick succession and turned out to be bestsellers, beginning with Ginsberg's *Howl* (1956); Kerouac's *On The Road* (1957); and a Paris edition (Olympia Press) that was banned in America of Burroughs' *Naked Lunch* (1959). (For their other publications, see the biographical sketches.) But it was more than exclusively literary fame which was coming their way. Countless young readers were attempting to copy the lifestyle embodied by the central characters in *On the Road* and *The Subterraneans*. Soon not only Hollywood, but Madison Avenue as well, began trying to cash in on the Beats' way of life and market "Beatnik" chic. Ginsberg and his friends found themselves being made into cultural stereotypes and figures of scandal overnight.

To escape this hysteria, the best approach seemed to be to travel abroad as often as possible. One of Ginsberg and Kerouac's first such journeys was to Tangier in 1957, where Burroughs was living. They helped Burroughs type the manuscript of *Naked Lunch* (its title suggested by Kerouac), and were introduced to two of his friends, the writers Brion Gysin and Paul Bowles. Kerouac tended to feel unwell when he traveled abroad, and he soon returned to New York, increasingly seeking refuge in alcohol. Ginsberg, Orlovsky, and Corso, on the other hand, took Tangier as the starting-point for their first extended European tour. They rounded their trip off with a lengthy stay at the pension in Paris at 9 Rue Git-le-Coeur, which came to be known as the "Beat Hotel."

In 1961, Ginsberg again set out from Tangier. This time his destination was India, and then Japan, followed by a poetry conference in Vancouver that was to mark a growing acceptance of the writings of the Beats in academic circles.

By this point those writings virtually belonged to the past, for Timothy Leary's experiments at Harvard with psilocybin and LSD and the cross-country bus trips of Ken Kesey and the Merry Pranksters were soon to herald the next phase of alternative culture: the birth of flower power and the blossoming of the Haight-Ashbury.

PAGE 33. Jack Kerouac in Burroughs' Garden Villa Mouneria Tanger 1957, he was retyping "Interzone" section of Naked Lunch manuscript for Bill.

PAGE 34. Peter Orlovsky and Jack Kerouac squinting in morning sunlight, William Burroughs prone observing in his olive green army jacket, Tanger port docks behind them, & customs house, where Peter & I landed on Yugoslavian freighter—Kerouac left April 5, 1957, so this was in week before.

PAGE 35. Peter Orlovsky legs crossed, William Burroughs with camera and hat for sun, myself white pants, Alan Ansen (W. H. Auden's & Burroughs' part time amanuensis), Gregory Corso sunglassed & Minox'd, the late Ian Sommerville (Burroughs' strobiscope-electronics sound assistant technician) on right, Paul Bowles seated squinting in bright noon light along Burroughs' doorway-garden wall, 1961 Tangier. My camera likely in Michael Portman's hands.

PAGE 36. LOWER. Allen Ginsberg, Wm. Burroughs, Gregory Corso, snapped by Peter Orlovsky with my Retina Kodak, Bill's doorway on to garden at Villa Mouneria, Tanger, 1961.

PAGE 36. UPPER. Gregory Corso, Paul Bowles, William Burroughs, behind him two dead boys: Ian Sommerville & Michael Portman, under the wall of Bill's Garden, Villa Mouneria Tanger 1961.

PAGE 37. William S. Burroughs by garden wall outside his room Villa Mouneria Tanger Maroc 1961, slightly zonked looking suspiciously at me: "Who are you an Agent for precisely?" He was then working out literary cut-up montage techniques.

PAGE 38. William Seward Burroughs Tanger Villa Mouneria 1961, his garden room, time of intense cut-up prose experiments, Nova Express tracing controllers of hypertechnologic planetary disaster "along the word lines" of their propaganda imagery back to the "image bank." Probably "a trust of giant insects in another galaxy" manipulating their human hosts to wreck the earth with radioactive crap so another life form could move in and take over the territory.

PAGE 39. Paris 1957 Gregory Corso, his attic 9 Rue Gît-le-Coeur. "Death" & "Clown" Poems.

PAGE 40. A modest portrait, Allen Ginsberg & Gregory Corso, Tangier 1961, camera in Peter Orlovsky's hand, our whitewashed room downstreet from Burroughs' Villa Mouneria.

PAGE 41. Gregory Corso and myself double portrait poetry Siamese twins, my room Tanger, Maroc, 1961. P. Orlovsky snapshot, my camera.

PAGE 42. Morning rooftop visit, Brahmin's house on Dasasumedh Ghat, Benares India 1963, Ganges river, temple Math tops and further shore visible, we had a room overlooking market vegetable meat piles on side and street alley way to Ghat where bathers washed, other side below our balcony. Monkeys stole bananas from room where I stayed half year with Peter Orlovsky who snapped this moment with my Kodak Retina. See Indian Journals for more.

PAGE 43. Gary Snyder then studying Zen Buddhism at Daitoku-ji precinct's First American Zen Institute, & translating Zen Dust a study of Koans, here

at rest in café probably on Juniken-doro street, Kita-ku section of Kyoto Japan, June 1963.

PAGE 44. Sea of Japan, travelling with Gary Snyder and wife Joanne Kyger, after year and half in India, on way home to Vancouver Poetry Conference, July 1963.

PAGE 45. Jerry Heiserman (later Sufi "Hassan"), the late "Red" a poet, Allen Ginsberg, Bobbie Louise Hawkins Creeley, Warren Tallman, Robert Creeley above Charles Olson, left to right top rows; seated left Thomas Jackrell then student poet, Philip Whalen & Don Allen anthologist & Postmodern Poetics editor, last days of Vancouver Poetry Conference late July 1963, car parked in front of host Professor Tallman's house—he'd sent me a ticket to come back from year and half in India for the assembly—which included Robert Duncan & Denise Levertov.

PAGE 46. Philip Whalen, Jerry Heiserman & Thomas Jackrell (who'd written poem about Campbell Soup Factory in Camden N.J.) sightseeing in Phil's old college town Portland Oregon on way back from Vancouver British Columbia Poetry Conference—Jackrell had an old van truck and drove us down the U.S. Northwest Coast to the Bay Area, July 1963, to San Francisco.

PAGE 47. Timothy Leary visiting Neal Cassady who drove Prankster Bus to Millbrook Psychedelic Research Center, Election Year 1964.

PAGE 48. Neal Cassady and I went upstairs to attic at Millbrook estate Costalia Foundation big house where Timothy Leary and friends were then experimenting with D.M.T., a half-hour trip—here Neal resting eyes-closed with Millbrook lady friend in charge of holding the vial of liquid psychedelica. I'd driven upstate from New York City with Ken Kesey's Merry Pranksters in their day-glo painted bus, recently arrived East cross country from California, Neal at the wheel, Fall 1964.

PAGE 49. Jack Kerouac on visit to Manhattan, last time he stopped at my apartment 704 East 5th Street, Lower East Side, he then looked like his father, corpulent red-faced W. C. Fields yawning with mortal horror, eyes closed a moment on D.M.T. visions—I'd brought some back from Millbrook where I'd recently been with Neal Cassady in Kesey's bus, pre-election 1964 Fall.

new york 1984-1991

PAGE 51. View out my kitchen window August 18, 1984, familiar Manhattan backyard, wet brick-walled Atlantis sea garden's ailanthus (stinkweed Tree of Heaven) boughs waving in rainy breeze, Stuyvesant Town's apartment roof two blocks north on 14th street. I focused on the raindrops on the clothsline.

PAGE 52. Herbert Huncke, New York, 1984, my kitchen, at the table, wry conversation—his new manuscript Guilty of Everything still to be edited.

PAGE 53. Robert Creeley one-eyed poet at Naropa Institute poetics commune house, summer session July 1984, he sat patient with me across supper table before his lecture, old friend.

PAGE 54. William Burroughs, Varsity Townhouse apartment, Naropa Institute, Boulder, Colorado July 1984, his annual visit to our Buddhist College. Here listening to recent poetry-music tapes I made, probably White Shroud vocalized with string quartet, or Elvin Jones on Hum Bom sound poem.

PAGE 55. Richard Avedon, his studio September 1984. Twenty years earlier he'd taken classic portrait of Peter Orlovsky and me naked arms round each other's waists. He invited us back to pose the same, older. I brought my camera too.

PAGE 56. Lou Reed poet musician in green room at makeup table, Public Theater on Lafayette Street New York, September 1984, he came invited by Rose Lesniak, above, to be Master of Ceremonies at premiere of video-poetry-music shorts by Anne Waldman (Oh oh Plutonium!) and myself (Father Death Blues).

PAGE 57. Robert and Pablo Frank visiting from Bronx State Hospital, my living room on East 12th Street New York, October 1984. Same noses.

PAGE 58. Francesco Clemente and C. T. Nachiappan (his printer host in Madras at Kalackshetra Press) at Kiev Restaurant on Second Avenue & 7th Street October 1984, we wandered over to Ramana Meharshi center on 6th street later on.

PAGE 59. Kay MacDonough, their son Nile, and father Gregory Corso at home, Telegraph Hill San Francisco October 1984 as prophesied in his poem Marriage (1959): "...and she gives birth to a child and I am sleepless, worn/up for nights, head bowed against a quiet window/the past behind me..."

PAGE 60. Lawrence Ferlinghetti in his office with Pooch, Whitman photo, files, coat racks, book bags, posters, at City Lights up on balcony, B'way and Columbus Avenues, San Francisco, October 1984.

PAGE 61. The Burroughs mob; Stewart Meyer (Lotus Crew memoirist) driver, Ira Silverberg, John Giorno poet, Andrew Wylie agent, James Grauerholz Bill's secretary and Ira's boyfriend, and shrunken Godfather Wm. S. Burroughs, in his "Bunker" loft 222 Bowery New York January 19, 1985.

PAGE 62. Raymond Foye, curator of my first photography show, and Holly Solomon, private dinner party at her apartment January 1985. I was still excited, snapping pictures that month. This print for Raymond with love, and thankfulness.

PAGE 63. Kathy Acker in green room, Detroit Institute of Arts, one night February 1985 we read together with Diane Di Prima—she writes violent-sexed feminist narratives, parody or imaginative love-torture novels, lives in London, first published chapters of books as pamphlets I found in the mail from Lower East Side New York.

PAGE 64. Dick McBride, Shigeyoshi Murao both City Lights Bookshop pioneers, and poet Jack Micheline, thru doorway of Trieste Café, San Francisco's North Beach, my reflection in glass with leather jacket back from Shanghai a few months earlier, March 16, 1985.

PAGE 65. Front of Trieste Café Grant & Vallejo Street San Francisco California—on corner Neeli Cherkovski & his friend Dr. Jesse Cabrera, Gregory Corso holding son Nile, Kay MacDonough behind them, March 16, 1985—street painter foreground daubing the café, morning haunt of North Beach poets & bohemians to this day.

PAGE 66. Gathering at Henry Geldzahler's house backyard 9th Street New York the afternoon before Francesco Clemente's double vernissage (at) Mary Boone/Leo Castelli Galleries March 30, 1985: John Giorno, Geldzahler, Allen Ginsberg, Clemente, William Burroughs, Alan Ansen visiting from Athens—Jim Grauerholz & his boyfriend at the time Ira Silverberg peeking over Burroughs' shoulder (J. G. Burroughs' secretary). Camera in Raymond Foye's hands.

PAGE 67. Sandro Chia had been shooting in Rhinebeck with William Burroughs a week before—here with his shotgun in's studio-apartment New York April, 1985—Julian Schnabel's portrait of him on the wall—I liked the magic romantic surreal tricks in his canvasses that year, much like G. Corso's poetry he illustrated in a rare large book. Big guy, big atelier—those painters make a lot of money. A Rhinebeck estate!

PAGE 68. Ed Sanders in his leafy front yard, Woodstock New York June 30, 1985 trying to put hubcap back on his tire, I was on way to visit Karmapa Monastic Center, top of nearby mountain, he was working with revived Fugs Poetry Rock Band, inventing "electronic lyre" and tuning Sappho's mixolydian verse.

PAGE 69. Poet Amiri Baraka (LeRoi Jones) at picnic outside Naropa Institute (first accredited Buddhist College in Western World). A Marxist, old friend from late 1950's Beat Poetry days New York, he taught Black literature with us at "Jack Kerouac School of Disembodied Poetics," tho a little suspicious of our meditation practice. August 1985.

PAGE 70. Anne Waldman, orator poet directress of Naropa Institute Poetics School at Jane Faigao's table, August 15, 1985. Robert Frank's The Americans under her wrist.

PAGE 71. Norman Mailer joined William Burroughs at Naropa Institute summer 1985 to spend a week & end with symposium on "The Soul: Is there One, What is it & What's Happening to It"—here leaving John Steinbeck IIIs backyard after visit.

PAGE 72. Willem de Kooning in his studio Springs, L.I. September 13, 1985, I visited with my stepmother Edith, his fly was unbuttoned, he said of his canvasses, "I'm just a sign-painter."

PAGE 73. Yevgeny Yevtushenko, his night suppertable loaded with cabbage soup, vodka, bread, pickled mushrooms, conversation in his dascha, Peredelkino an hour's drive out of Moscow, December 1985. My interpreter with glasses, listening, had said (as Russian yuppie journalist), "I know what buttons to push, who to telephone, I can get along with this system," in the car on the way out.

PAGE 74. Gregory Corso visiting cross on top the grotto Kerouac immortalized in Book 4 Chapter 1, Dr. Sax—here memère knelt and prayed too. Lowell Massachusetts, March 17, 1986.

PAGE 75. Peter Orlovsky eating Chinese take-out supper with Peter Hale, young ex-Naropa now classics student, our apartment kitchen, Manhattan December 2, 1986.

PAGE 76. Philip Whalen, Sensei, staying over in my bedroom East 12 Street, visiting New York from Santa Fé Zen Center, he'd read poetry & lectured in my Brooklyn College class "Literary History of the Beat Generation" a week before. March 16, 1987.

PAGE 77. William Burroughs, film interview Soho New York December 21, 1986, secretary Jim Grauerholz leaning forward observing discussion of world of 1940's, memoirs.

PAGE 78. Peter Orlovsky b. 1933 visiting his family—Lafcadio age 47 had lived with us in San Francisco—N.Y. 1955-61 & later intermittent years; mother Kate Orlovsky age 78 totally deaf after botched mastoid operation N.Y. Eye & Ear Hospital 1930's; Laff's twin sister Marie who'd lived with me & Peter O. in Lower East Side 1959 while she attended baby nurse school in Jersey—but quit jobs soon after, angry at hearing voices' filthy gossip behind her back. Center Moriches Long Island, their second floor flat on lonely road, they need taxi to supermarket shopping miles away with S.S.I. checks. July 26, 1987 visit.

PAGE 79. Gary and Masa Snyder after supper in their kitchen, "Kitkitdizze" on San Juan Ridge, a Japanese style farm house 3000 feet up in park-like oak and ponderosa pinewoods on Western Slope of Sierras near Nevada City California, May 30, 1988.

PAGE 80. William Seward Burroughs relaxing on old broken down foam-rubber couch in sideyard of his house, looking up through tree tops to the sky, Lawrence, Kansas, May 28, 1991. ◗

biographical sketches

FOR REASONS OF SPACE, ONLY THOSE PEOPLE WHOSE INDIVIDUAL PHOTOGRAPHS ARE INCLUDED HERE HAVE BEEN ALLOTTED BIOGRAPHICAL ENTRIES. IN ORDER TO DISTINGUISH THE WRITERS OF THE BEAT GENERATION IN THE NARROWER SENSE, THE DATE AND MONTH OF THEIR BIRTH ARE GIVEN; OTHERWISE ONLY THE YEAR OF BIRTH IS INDICATED. THE BIBLIOGRAPHICAL INFORMATION IS RESTRICTED TO THE

MOST IMPORTANT ENGLISH-LANGUAGE EDITIONS OF POEMS, SHORT STORIES, ESSAYS, AND INTERVIEWS.

IN THE BIOGRAPHICAL ENTRIES THE FOLLOWING SYMBOLS AND ABBREVIATIONS HAVE BEEN USED:

* INDICATES A CROSS-REFERENCE
LP = LONG-PLAYING RECORD
TC = CASSETTE RECORDING
CD = COMPACT DISC

BERENICE ABBOTT

b. Springfield, Ohio, 1898

d. 1991

Pl. 13

Photographer. 1921–23: studies with Man Ray in Paris and is introduced by him to Eugène Atget. Acquires Atget's archives and earns a worldwide reputation both for him and for her own work. 1930–68: works from the Studio for Architectural and Portrait Photography in Manhattan. Lived in Abbot Village, Maine, from 1968 until her death in 1991. A classic of modern American photography, Abbott has had countless publications and exhibitions throughout the world. Her principal work was *Changing New York* (1939), a documentary study taken over a period of ten years that chronicled the changing architectural face of New York. In 1982 a comprehensive edition of her work was published. In 1981 she was presented with the Association of International Photo Art Dealers award for Outstanding Contributions to the Field of Photography.

BOOKS: *CHANGING NEW YORK* (1939), REPRINTED AS *NEW YORK IN THE THIRTIES* (1973), *GREENWICH VILLAGE TODAY AND YESTERDAY* (1949), *THE WORLD OF ATGET* (1964), *THE ATTRACTIVE UNIVERSE* (1967), *A PORTRAIT OF MAINE* (1968), *BERENICE ABBOTT: SIXTY YEARS OF PHOTOGRAPHY* (1982).

KATHY ACKER

Pl. 63

Major postmodernist fiction writer and cultural subversive. Because she does not offer details about her life, information comes from indirect sources. According to these, she was born in 1947, grew up in New York City, and studied at Brandeis University. Her early prose appeared in 1973. She has written twelve novels to date as well as plays, a libretto, and a screenplay. During the eighties she lived in London. She has since returned and at present lives in San Francisco. "She is the wildest author anywhere, piercing, dry, obscene, cynical and brutally honest" (*The Village Voice*).

BOOKS: *THE CHILDLIKE LIFE OF THE BLACK TARANTULA* (1973), *THE ADULT LIFE OF TOULOUSE LAUTREC* (1974), *FLORIDA* (1976), *BLOOD AND GUTS IN HIGH SCHOOL* (1978), *KATHY GOES TO HAITI* (1979), *I DREAMT I WAS A NYMPHOMANIAC IMAGINING* (1980), *GREAT EXPECTATIONS* (1982), *MY DEATH, MY LIFE, BY PIER PAULO PASOLINI* (1983), *DON QUIXOTE* (1986), *EMPIRE OF THE SENSELESS* (1989), *LITERAL MADNESS* (1989), *IN MEMORIAM TO IDENTITY* (1990), *HANNIBAL LECTER, MY FATHER* (1991), *PORTRAIT OF AN EYE* (1992), *MY MOTHER: DEMONOLOGY* (1993).

RICHARD AVEDON

b. New York City, 1923

Pl. 55

Leading figure in international fashion photography in addition to being a world-renowned portrait photographer. Studied philosophy at Columbia University. Studied photography under Alexy Brodovitch at The New School, Manhattan. From 1945 to 1965 senior photographer for *Harper's Bazaar*. In 1966 left *Harper's* for *Vogue*. During the late sixties and early seventies photographs anti-war protesters and military leaders and war victims in Vietnam. Numerous exhibitions, including the full-scale retrospective *Avedon: Photographs 1947–'77* at the Metropolitan Museum of Art in New York, 1978. In 1992 he is appointed first staff photographer for *The New Yorker*. In 1994 his lavishly illustrated *Autobiography* is published to considerable acclaim, and the Whitney Museum of American Art holds a retrospective of Avedon's work.

BOOKS: *IN THE AMERICAN WEST, PHOTOGRAPHS 1979–1984* (1987), *AUTOBIOGRAPHY* (1993), *RICHARD AVEDON: EVIDENCE 1944–1994* (1994).

IMAMU AMIRI BARAKA

(LeRoi Jones)

b. Newark, New Jersey, 1934

Pl. 69

Poet, playwright, essayist, and social activist, major force for over thirty years in African-American culture. 1954–57: military service with the U.S. Air Force in Puerto Rico and the Federal Republic of Germany. Studies German literature at Columbia University, New York. Edits magazine *Yugen* and the *Totem Press*, and publishes work by Charles Olson and Robert *Creeley among others. 1963–65: teaches literature at The New School, Manhattan. In 1964 his one-act play *Dutchman* wins Obie Award for best off-Broadway production. Late sixties breaks with white America, renounces "slave name" Leroi Jones and founds Spirit House, an African-American community center in Newark, New Jersey. Continues to be active in politics both on local and national level. Avowed Marxist-Leninist; strident

critic of racism and imperialism. Since 1979, professor in the African Studies Department at the State University of New York at Stony Brook (in 1984 becoming full tenured professor). In 1989 receives the American Book Awards Lifetime Achievement Award. Retrospective anthology, *The LeRoi Jones/Amiri Baraka Reader,* published in 1991. He is author of over twenty plays, three jazz operas, seven nonfiction books and thirteen volumes of poetry. "Always a nuance ahead of everyone else, he is our most original writer. Nobody else comes close" (Ishmael Reed).

BOOKS: *PREFACE TO A TWENTY-VOLUME SUICIDE NOTE* (1961), *BLUES PEOPLE* (1963, 1980), *THE DEAD LECTURER* (1964), *DUTCHMAN AND THE SLAVE* (1964), *THE SYSTEM OF DANTE'S HELL* (1965), *HOME: SOCIAL ESSAYS* (1966), *TALES* (1967), *THE BAPTISM AND THE TOILET* (1967), *BLACK MUSIC* (1967, 1980), *BLACK MAGIC: COLLECTED POETRY 1961–67* (1968), *IN OUR TERRIBLENESS* (1970), *JELLO* (1970), *RAISE RACE RAYS RAZE: ESSAYS SINCE 1965* (1971), *SPIRIT REACH* (1972), *HARD FACTS* (1975), *IT'S NATION TIME: THE MOTION OF HISTORY AND OTHER PLAYS* (1978), *SELECTED POETRY OF AMIRI BARAKA/LEROI JONES* (1979), *SELECTED PLAYS AND PROSE OF AMIRI BARAKA/LEROI JONES* (1979), *REGGAE OR NOT* (1981), *THE AUTOBIOGRAPHY OF LEROI JONES/AMIRI BARAKA* (1984), *DAGGERS AND JAVELINS: ESSAYS 1974–79* (1984), *THE MUSIC: REFLECTIONS ON JAZZ AND BLUES* (1987), *THE LEROI JONES/AMIRI BARAKA READER* (1991).

WILLIAM SEWARD BURROUGHS

b. St. Louis, Missouri, 5 February 1914

Pl. 21–23, 34–38, 54, 61, 66, 71, 77, 80

Novelist. According to *Ginsberg, Burroughs is an "original genius with an infallible ear for speech patterns and an eye for hypnotic details, the inventor of new prose forms." Upper middle-class upbringing in St. Louis (grandson of adding machine inventor). 1932–36: Harvard College, Cambridge, Massachusetts. 1936–37: travels in Europe, including a term spent studying medicine in Vienna. 1938–42: Harvard University, where he majors in ethnology. Brief period of military service. Application to join the Secret Service is turned down. Casual jobs as barman, exterminator, and private detective in Chicago and New York. Becomes friendly with Ginsberg and *Kerouac in 1944. Excursions into the hipster world of Times Square. Experiments with drugs lead to drug addiction. Becomes friendly with Herbert *Huncke. Marries Joan Vollmer, a friend of Kerouac's wife, Edie Parker. 1946–49: on the run from American narcotics agents, lives first on his own farm at New Waverly, Houston, Texas, where he grows marijuana, then on another farm at Algiers, New Orleans, Louisiana, before going to Mexico. Lives in Mexico City from 1949 to 1952. Accidentally shoots his wife. During the trial he works on *Junkie,* a novel about his experiences with drugs. Leaves Mexico to escape sentence and in 1953 travels through Central America in search of the wonder drug *yage.* Spends the autumn of 1953 with Ginsberg in New York and works with him on *The Yage Letters.* From 1954 to 1958 lives in Tangier, Morocco, while in the final stages of addiction and almost incapable of movement. In 1957 successfully undergoes apomorphine treatment in London. Writes *Naked Lunch* (so named by Kerouac). Becomes friendly with Brion Gysin and Paul Bowles. From 1958 to 1965 lives in Paris, with lengthy visits to London and Tangier. *Naked Lunch* appears. Earliest experiments in "cut-up," a technique devised by Gysin and deployed in Burroughs' later novels. Participates in Timothy *Leary's experiments with "mind-expanding" drugs but finally distances himself from Leary's methods of research. A prosecution against *Naked Lunch* in the United States ends with the novel's being judged "not obscene." Lives in London from 1966 to 1974. Experiments with films and tape recordings using cut-up technique. Establishes himself as cultural icon. Two major interviews for *Rolling Stone.* Reports on 1968 Democratic Party convention in Chicago for *Esquire.* Briefly joins the Church of Scientology. Returns to a linear narrative style in 1971 with *The Wild Boys.* Lives in New York from 1974 to 1981. During the summer holds regular classes at the Jack Kerouac School of Disembodied Poetics in Boulder, Colorado. Writes a column for the rock magazine *Crawdaddy.* Significant influence on seventies punk (and eighties and nineties offshoots). During the 1980s completes a major trilogy with *Cities of the Red Night* (1981), *The Place of Dead Roads* (1983), and *The Western Lands* (1987). He turns his hand to painting, combining "shotgun art" chance and calligraphy with collage; has several major international exhibitions. Since 1981 he has lived in Lawrence, Kansas, the home of James Grauerholz, his secretary and administrator. In 1984 he was made a member of the American Academy of Arts and Letters.

BOOKS: *JUNKIE* (1953), *NAKED LUNCH* (1959), *THE SOFT MACHINE* (1961), *THE TICKET THAT EXPLODED* (1962), *THE YAGE LETTERS* (1963), *DEAD FINGERS TALK* (1963), *NOVA EXPRESS* (1964), *THE JOB: INTERVIEWS WITH WILLIAM S. BURROUGHS* (1989), *THE LAST WORDS OF DUTCH SCHULTZ* (1970), *THE WILD BOYS* (1971), *EXTERMINATOR!* (1973), *PORT OF SAINTS* (1973), *AH POOK IS HERE* (1979), *BLADE RUNNER: A MOVIE* (1979), *CITIES OF THE RED NIGHT* (1981), *THE PLACE OF DEAD ROADS* (1983), *WESTERN LANDS* (1984), *THE BURROUGHS FILE* (1984), *THE ADDING MACHINE: COLLECTED ESSAYS* (1985), *QUEER* (1985), *INTERZONE* (1990), *PAINTING AND GUNS* (1992), *THE CAT INSIDE* (1992), *LETTERS OF WILLIAM BURROUGHS 1945–59* (1993).

RECORDINGS: *DEAD CITY RADIO* (1990), *SPARE ASS ANNIE* (1993).

BIOGRAPHIES: TED MORGAN, *LITERARY OUTLAW* (1988), BARRY MILES, *EL HOMBRE INVISIBLE* (1993).

FILM/VIDEO: *BURROUGHS: THE MOVIE,* DIRECTED BY HOWARD BROOKNER (1985).

NEAL CASSADY

b. Salt Lake City, Utah, 8 February 1926

d. San Miguel de Allende, Mexico 4 February 1968

Pl. 26–29, 48, 49

As the legendary personification of "a life of fast living, a life high on jazz and drugs, sex, and freedom," Cassady is a key figure of the Beat Generation. Childhood under "supervision" of a flophouse proprietor. Between the ages of fourteen and twenty-one steals more than 500 cars (by his own reckoning). Frequent periods in approved schools in consequence. In 1947 becomes friendly with *Ginsberg and *Kerouac in New York. Is the model for Dean Moriarty, the main character in Kerouac's *On the Road.* During the 1950s works as a brakeman on Southern Pacific Railroad in San Francisco. Marries Carolyn Robinson. In 1957 brief *menage à trois* involving the Cassadys and Kerouac (see Carolyn Cassady, *Heart Beat*). Between 1958 and 1960 serves term of imprisonment in San Quentin for illegal possession of two joints of marijuana. In 1964 becomes Ken Kesey's driver on the Merry Prankster bus tour to Timothy *Leary's psychedelic commune in Millbrook, New York (described by Tom Wolfe in *The Electric Kool Aid Acid Test,* 1968). Dies from an overdose of alcohol and sleeping tablets. His body is found beside the railway tracks at San Miguel de Allende, Mexico.

BOOKS: *THE FIRST THIRD AND OTHER WRITINGS* (1971), *AS EVER: THE COLLECTED CORRESPONDENCE OF ALLEN GINSBERG AND NEAL CASSADY* (1977), *GRACE BEATS KARMA: LETTERS FROM PRISON 1958–60* (1993).

SANDRO CHIA

b. Florence, Italy, 1946

Pl. 67

Painter. With Francesco *Clemente a leading representative of the *transavanguardia* or Expressionist art revival in Italy, Germany, and the United States in the late 1970s

and early 1980s. Studies at the Academy of Art in Florence. Early training focused exclusively on traditional materials and techniques of painting is abandoned in the late sixties for experiment with conceptually-based installations and process art. First one-man show at Galleria La Salita, Rome, 1972. In mid-seventies returns to painting figurative canvases and begins reinterpreting a succession of historical genres. Travels throughout Europe and India. Settles in Ronciglione, near Rome, in 1970. Later work typically vast canvases dominated by mythical figures rendered with conflict-ridden brush stroke. Brief period in Mönchengladbach, Germany, 1980–81. Since 1980 has divided his time between New York (Chelsea studio and Rhinebeck hunting estate) and Italy. Has exhibited—and continues to exhibit—worldwide.

FRANCESCO CLEMENTE
b. Naples, Italy, 1952
Pl. 58, 66

Painter. With Sandro *Chia, a leading representative of the transavanguardia or Expressionist art revival in Italy, Germany, and the United States and one of the most significant contemporary painters. Studies classical literature, then architecture, in Rome. Extended visits to India and Afghanistan. Since 1983 has divided his time among Rome, New York, and Madras. Exhibitions throughout the world. In 1984 he illustrates a limited edition of *Ginsberg's poems, White Shroud. Has also collaborated with poets John Wieners and Gregory *Corso and, most recently, prose-poet Harry Mathews. (Raymond Foye's Francesco Clemente: Three Worlds is the most detailed exploration of his work to date.) Together with Foye, he is co-publisher of Hanuman Books, a series of small books that has featured Ginsberg and many of the other Beat writers among its titles.

GREGORY CORSO
b. New York City, 26 March 1930
Pl. 35, 36, 39–41, 59, 65, 74

Leading poet and enfant terrible of the Beat Generation. "A tough young kid from the Lower East Side who rose like an angel over the rooftops" (Jack *Kerouac). Childhood spent in orphanages and approved schools. In 1950 becomes friendly with *Ginsberg, who encourages him to write. Two years at Harvard College, Cambridge. Since then has divided his time between New York and San Francisco, with longer stays in Europe, North Africa, and Mexico. He has taught at the State University of New York at Buffalo and at the Naropa Institute, Boulder, Colorado. His first book of poems, The Vestal Lady of Brattle, was published in 1955. Since then he has published six major collections. Kenneth Rexroth, an early critic, observed, "Where he is weakest, he is an amusing curiosity; where he is strongest, his poems become metaphysical whirlwinds and poetic cannon shots." Allen Ginsberg has more recently noted, "Corso is a poet's poet, his verse pure velvet, close to John Keats for our time, exquisitely delicate in manners of the Muse."

BOOKS: THE VESTAL LADY OF BRATTLE (1955), GASOLINE (1958), THE HAPPY BIRTHDAY OF DEATH (1960), THE AMERICAN EXPRESS (1961), LONG LIVE MAN (1962), ELEGIAC FEELINGS AMERICAN (1970), HERALD OF THE AUTOCHTHONIC SPIRIT (1981), MINDFIELD: SELECTED AND NEW POEMS (1989).

ROBERT CREELEY
b. Arlington, Massachusetts, 1926
Pl. 45, 53

Poet, prose-writer, and essayist. Studies at Harvard University, Cambridge, 1951–52; lives in Aix-en-Provence and Majorca. Epistolary friendship with Charles Olson, then Rector of Black Mountain College, North Carolina. (See The Complete Correspondence, Vols. 1–8, 1980–85.) In 1954–55 lectures at Black Mountain College and edits Black Mountain Review. From 1957 to 1965 various teaching appointments in New Mexico, Guatemala, and Canada. Since 1966 faculty member of the State University of New York at Buffalo (he is currently Samuel P. Capen Professor of Poetry and Humanities). First volume of poems, Le Fou, published in 1952. Breakthrough volume For Love (1962). Since then, with distinctive ear and unique minimal form, has established himself as one of the most important poets of the century. Travels extensively, giving lectures and readings at universities and community centers around the world. Numerous publications and awards (among them the Horst Bienek Lyrikpreis from the Academy of Fine Arts, Munich, and the Walt Whitman Citation: New York State Poet 1989–91). His Collected Poems 1945–1975 are published in 1982, followed soon after by collections of his essays and prose. His own Selected Poems appears in 1991. Recently completed editing edition of The Selected Poems of Charles Olson. A member of the American Academy of Arts and Letters. The poet John Ashbery has written that his poems are "as basic and necessary as the air we breathe, as hospitable, pleasant, and open as our continent itself. He is about the best we have."

BOOKS: LE FOU (1952), THE GOLD DIGGERS (1954), FOR LOVE (1962), THE ISLAND (1963), WORDS (1967), PIECES (1969), THE CHARM (1969), A QUICK GRAPH: COLLECTED NOTES AND ESSAYS (1970), A DAY BOOK (1971), CONTEXTS OF POETRY: INTERVIEWS 1961–1971 (1972), WAS THAT A REAL POEM AND OTHER ESSAYS (1972), HELLO: A JOURNAL (1976), MABEL: A STORY (1976), LATER (1979), THE COLLECTED POEMS OF ROBERT CREELEY 1945–1975 (1982), MIRRORS (1983), THE COLLECTED PROSE OF ROBERT CREELEY (1984), MEMORY GARDENS (1986), WINDOWS (1990), THE COLLECTED ESSAYS OF ROBERT CREELEY (1989), AUTOBIOGRAPHY (1990), SELECTED POEMS OF ROBERT CREELEY (1991), TALES OUT OF SCHOOL: SELECTED INTERVIEWS (1994), ECHOES (1994).

RECORDINGS: FOR LOVE, S PRESS, TC (1975).

WILLEM DE KOONING
b. Rotterdam, Holland, 1904
Pl. 72

Painter. The leading figure of Abstract Expressionism—a painting style that, after World War II, established New York as the world capital of avant garde art. Educated in Holland. In 1927 moves to New York. Earns his living as commercial artist, carpenter, furniture designer, house painter. In 1935 joins Works Progress Administration's Federal Arts Project, dedicates himself full-time to painting. In 1936 appears in group exhibit, "New Horizons in American Art," at Museum of Modern Art. First solo exhibition in 1948 at the Charles Egan Gallery. Since then has had numerous exhibitions throughout the world and has established himself as America's premier living painter. In 1984 is the subject of two full-scale retrospectives, "Willem de Kooning: Painting and Sculpture" and "The Drawings of Willem de Kooning," organized by the Whitney Museum, New York, the Akademie der Kunste, Berlin, and the Pompidou Center, Paris. Continues to paint into eighties. In 1963 relocates from downtown New York loft to the Springs on Long Island. Builds own studio. Celebrates his ninetieth birthday. Ginsberg has known him since the early fifties when Beat authors and Abstract Expressionists frequented the same bars (Cedar Tavern) in Greenwich Village and avidly discussed their work.

LAWRENCE FERLINGHETTI

b. Yonkers, New York, 24 March 1919

Pl. 26, 60

Poet, bookseller, and publisher. Lieutenant in the U.S. Navy Atlantic Fleet during World War II. Studies at Columbia University, New York; earns doctorate at the Sorbonne, Paris. Has lived in San Francisco since 1950. Founds City Lights Bookstore there in 1953, the first bookshop in the United States to deal solely in paperbacks. The following year inaugurates the paperback series, City Lights Books. Both still operate from their address on Broadway and Columbus Avenue. Publishes volumes of poetry by almost all the Beat writers. The obscenity trial in 1957 against his first edition of *Ginsberg's *Howl* makes both men world famous. Publisher of the periodicals *Beatitude, Journal for the Protection of All Beings,* and *City Lights Journal.* His first collection of original poems, *Pictures of the Gone World,* is published in 1955. In 1958 New Directions publishes *A Coney Island of the Mind.* Since then has published ten volumes of poetry, two collections of plays, a political satire, and two novels as well as translations of Prévert and Pasolini. Pioneered readings with jazz accompaniment. Recent years devoted to painting. Latest one-man show: Butler Museum of American Art (September 1993). Has been described as "one of our ageless radicals and true bards."

BOOKS: *PICTURES OF THE GONE WORLD* (1955), *A CONEY ISLAND OF THE MIND* (1958), *HER* (1960), *STARTING FROM SAN FRANCISCO* (1961), *UNFAIR ARGUMENTS WITH EXISTENCE* (1962), *ROUTINES* (1964), *AFTER THE CRIES OF THE BIRDS* (1967), *THE SECRET MEANING OF THINGS* (1969), *TYRANNUS NIX?* (1969), *OPEN EYE, OPEN HEART* (1973), *WHO ARE WE NOW?* (1976), *ENDLESS LIFE: SELECTED POEMS* (1981), *A TRIP TO ITALY AND FRANCE* (1981), *LEAVES OF LIFE* (1983), *SEVEN DAYS IN NICARAGUA LIBRE* (1984), *EUROPEAN POEMS AND TRANSLATIONS* (1984), *LOVE IN THE DAYS OF RAGE* (1989), *WHEN I LOOK AT PICTURES* (1990), *THESE ARE MY RIVERS: NEW AND SELECTED POEMS 1955–1993* (1993).

BIOGRAPHY: NEELI CHERKOVSKI, *FERLINGHETTI: A BIOGRAPHY* (1979).

RECORDINGS: *SAN FRANCISCO POETS*, LP (1957), *POETRY READINGS IN "THE CELLAR,"* WITH KENNETH REXROTH, FANTASY, LP (1958), *TENTATIVE DESCRIPTION OF A DINNER TO IMPEACH PRESIDENT EISENHOWER & OTHER POEMS*, FANTASY, LP (1959), *TYRANNUS NIX? AND ASSASSINATION RAGA*, FANTASY, LP (1971), *THE WORLD'S GREATEST POETS: VOLUME 1*, WITH ALLEN GINSBERG AND GREGORY CORSO, SPOLETO FESTIVAL, 1965, CMS, LP (1971), *CONTEMPORARY AMERICAN POETS READ THEIR WORKS*, LP (1972), *NO ESCAPE EXCEPT PIECE*, S PRESS, TC (1987).

ROBERT FRANK

b. Zurich, Switzerland, 1924

Pl. 57

Photographer and filmmaker. Studies photography in Basel and Zurich. Has lived in New York since 1947. Initially does freelance work for *Harper's Bazaar, Fortune, Life, Look,* and others, including assignments to South America and Europe. In 1955 receives Guggenheim grant to write a feature on the United States and spends a year traveling around the country by car with his family. The result is *The Americans* (1958), with a foreword by *Kerouac. The basic elegiac mood of Kerouac's text, together with Frank's predilection for the sad and trivial aspects of American life, cause it to be initially misinterpreted as an uncalled-for critique of the American Dream, and as such it is torn to pieces. Not until the 1960s does its Beat perspective on America, together with Frank's spontaneous camera style, allow the volume to be seen as an artist's manual for street photography. Since 1958 Frank has been primarily involved in making films. Founding member of the New American Cinema Group and of the Film-Makers Cooperative. Early films include *Pull My Daisy* (1959), with a script by Kerouac and a cast including *Ginsberg, *Orlovsky, *Corso, and Larry Rivers in the main roles, and *Me and My Brother* (1965), about Peter and Julius Orlovsky. In 1972 a full-length documentary, *Cocksucker Blues*, is commissioned by the Rolling Stones to document their U.S. tour; because of its heroin scenes it has never been commercially screened. Frank also makes cover art for their album *Exile on Main Street.* In 1982 a short film, *This Song for Jack,* celebrates the Beat reunion held at the Naropa Institute to mark the twenty-fifth anniversary of the first appearance of Kerouac's *On the Road.* Frank makes cover art for Ginsberg's 1982 album, *First Blues.* 1986: Museum of Fine Arts, Houston, and the Center for Creative Photography co-publish Stuart Alexander's *Robert Frank: A Bibliography, Filmography and Exhibition Chronology 1946–1983* and a new edition of *The Americans* in three languages. As Jack Kerouac wrote of Robert Frank, "You got eyes."

BOOKS: *THE AMERICANS: PHOTOGRAPHS* (1958, REVISED 1969, 1978, 1986, 1994), *PULL MY DAISY* (1961), *LINES OF MY HAND* (1971), *NEW YORK TO NOVA SCOTIA* (1987), *ROBERT FRANK/TEXT BY ROBERT FRANK* (1988), *ONE HOUR* (1992).

HERBERT HUNCKE

b. Greenfield, Massachusetts, 9 January 1915

Pl. 52

By providing *Burroughs, *Kerouac, and *Ginsberg with their first taste of the drug scene, Huncke became the prototype of hipsterism and Beat awareness in their works. "You'll meet him in Times Square, dreamy-eyed and wide awake, sad, sweet and dark, fresh from jail, a martyr. Tormented by the streets, hungry for sex and comradeship. Open to everything: ready to open up new worlds to you with a shrug of his shoulders," Kerouac wrote. After leaving school in Chicago hitchhikes around all forty-eight states. Moves to New York in 1940. Becomes friendly with Burroughs, Kerouac, and Ginsberg in 1945. In 1947 Burroughs takes him to East Texas. 1949–54: jail time. 1959: moves to Ginsberg's building on 2nd Street on New York's Lower East Side and with poet John Weiners on Avenue C. Village legend. Appears on the David Susskind television show in the sixties (discussing Kinsey memories). His *Huncke's Journal* appears in 1965. Fifteen years later, his collection of stories *The Evening Sun Turned Crimson.* Allen Ginsberg has written, "Huncke's prose proceeds from his midnight mouth, that is, literal storytelling, just talking—for that reason it is both awkward and pure. In his anonymity and holy creephood in New York, he was the sensitive vehicle for a veritable new consciousness which spread to others sensitized by their dislocation from history and thus to entire generations." An autobiography appeared in 1988, *Guilty of Everything.*

BOOKS: *HUNCKE'S JOURNAL* (1965), *THE EVENING SUN TURNED CRIMSON* (1980), *GUILTY OF EVERYTHING* (1988).

JEAN LOUIS (JACK) KEROUAC

b. Lowell, Massachusetts, 12 March 1922

d. St. Petersburg, Florida, 22 October 1969

Pl. 20, 21, 33, 34, 49

Author of fourteen novels and four books of poetry. Coined the term Beat Generation and gave expression to its existential feelings. Childhood and schooling in Lowell, attends Columbia University, New York, from 1940 to 1942. Works as a freelance writer. In 1942–43 serves in the U.S. Merchant Navy. Between 1943 and 1948 works on his first novel, *The Town and the City,* a traditional, semi-autobiographical account of his early years at home and at college. Becomes friendly with Neal *Cassady in 1946. During the next four years accompanies Cassady on various trips around the United States collecting material for his masterpiece, *On the Road. The Town and the City* appears in 1950 but meets with little response. Marries Joan Havarty. Inspired by Charlie

Parker's bebop solos and Cassady's "wild" epistolary style, he invents the principles of "spontaneous prose" and, early in 1951, "improvises" *On the Road* on a roll of continuous paper within the space of twenty days. In 1952 spends a longer period with the Cassadys in San Francisco, training to become a brakeman on Southern Pacific Railroad. Returns to New York in the autumn of 1953 and spends time with *Ginsberg and *Burroughs, which in turn provides material for *The Subterraneans*. In 1954 begins to teach himself Buddhism. In 1955 stays with Burroughs in Mexico City, collecting material for *Tristessa*. Afterward stays with Ginsberg in San Francisco and attends the historic reading in the Six Gallery that first brings Beat poetry to public attention. His friendship with Gary *Snyder up to the time of the latter's departure for Japan in May 1956 provides the starting point for *The Dharma Bums*. In the spring of 1957 visits Burroughs in Tangier together with Ginsberg, *Orlovsky, and *Corso. *On the Road* appears at the beginning of September and remains among the top ten best-selling books for the next five weeks, leading to publication, in rapid succession, of another four novels that Kerouac had already completed: *The Subterraneans* (spring 1958), *The Dharma Bums* (fall 1958), *Maggie Cassidy* (1959), and *Tristessa* (1960). The critics, however, remain largely negative, accusing him of formlessness and a nihilist outlook on the world. By the same token, the mass media notice only the youthful rebellious escapades of the Beat Generation, reducing their lifestyle to a predilection for drugs, free sex, and joy rides, as in the 1960 Hollywood version of *The Subterraneans* with George Peppard and Leslie Caron. Kerouac attempts in vain to distance himself from the beatnik bandwagon, seeking embittered refuge in alcohol. Once the fuss dies down in 1961, he lacks all motivation to write any more, not least because falling sales figures have drastically reduced the prospects of achieving a quick success. Suffers clinical depression, avoids New York, breaks off all contact with his former friends, marries Stella Sampas, a childhood friend from Lowell, drifts from place to place, including Long Island, Cape Cod, and Florida, and slowly but surely drinks himself to death.

BOOKS: *THE TOWN AND THE CITY* (1950), *ON THE ROAD* (1957), *THE DHARMA BUMS* (1958), *THE SUBTERRANEANS* (1958), *MEXICO CITY BLUES* (1959), *MAGGIE CASSIDY* (1959), *DOCTOR SAX* (1959), *TRISTESSA* (1960), *LONESOME TRAVELER* (1960), *BOOK OF DREAMS* (1961), *BIG SUR* (1962), *VISIONS OF GERARD* (1963), *DESOLATION ANGELS* (1965), *SATORI IN PARIS* (1966), *VANITY OF DULUOZ* (1968). POSTHUMOUSLY PUBLISHED: *VISIONS OF CODY* (1970), *PIC* (1971), *SCATTERED POEMS* (1971), *HEAVEN AND OTHER POEMS* (1977), *POMES ALL SIZES* (1992), *GOOD BLOND AND OTHER PIECES* (1993), *OLD ANGEL MIDNIGHT* (1993).

BIOGRAPHIES: ANNE CHARTERS, *KEROUAC* (1973), BARRY GIFFORD AND LAWRENCE LEE, *JACK'S BOOK—AN ORAL BIOGRAPHY OF JACK KEROUAC* (1978), DENNIS MCNALLY, *DESOLATE ANGEL* (1979), GERALD NICOSIA, *MEMORY BABE: A CRITICAL BIOGRAPHY OF JACK KEROUAC* (1988), TOM CLARK, *WRITER: A LIFE OF JACK KEROUAC* (1984).

FILM/VIDEO: *WHAT HAPPENED TO KEROUAC*, DIRECTED BY RICHARD LERNER AND LEWIS MACADAMS (1985).

RECORDING: *THE JACK KEROUAC COLLECTION* (1990).

TIMOTHY LEARY

b. Springfield, Massachusetts, 1920

Pl. 47

Psychologist and proponent of the use of mind-expanding drugs. Normal academic career until 1960, when he begins a research project on hallucinogens at Harvard University. His subjects include *Ginsberg, *Burroughs, and *Kerouac. Is given sabbatical leave in 1963 when it is alleged that LSD was given to one student. Founds Castalia Foundation in Millbrook, New York, in order to continue his experiments with LSD. His saying "Turn On, Tune In, Drop Out" becomes a slogan of the hippie revolution. In 1969 is sentenced to ten years' imprisonment for possessing marijuana. Flees the country but is rearrested by the CIA in Afghanistan. Paroled for good behavior in 1976. Since then has lectured on futurology and created "mind-expanding" computer games. Most recently he has been a propagandist for "cyberspace" and "virtual reality" technology.

BOOKS: *THE POLITICS OF ECSTASY* (1968), *HIGH PRIEST* (1969), *JAIL NOTES* (1970), *CONFESSIONS OF A HOPE FIEND* (1973), *COMMUNICATION WITH HIGHER INTELLIGENCE* (1977), *FLASHBACKS: AN AUTOBIOGRAPHY* (1983), *AUTOBIOGRAPHY* (1983), *INFO-PSYCHOLOGY* (1987), *GAME OF LIFE* (1989), *NEUROPOLITIQUE* (1991).

PETER ORLOVSKY

b. New York City, 8 July 1933

Pl. 30, 31, 34, 35, 75, 78

Poet and *Ginsberg's companion. Youth spent in slums on Lower East Side. Since 1955 has taken part in all the important activities of the Beat writers. Has accompanied Allen Ginsberg at numerous poetry readings on banjo and guitar. First poetry pamphlet, *Dear Allen*, published in 1971. Aided by poet Ted Berrigan, in 1978 makes a collection of his writings for City Lights, *Clean Asshole Poems and Smiling Vegetable Songs*. "Peter is an original; a refined spirit . . . an agricultural romantic; the Shelleyan farmer astride his Pegasusian tractor [he] re-poems the earth" (Gregory Corso). In 1980, *Straight Hearts' Delight: Love Poems and Selected Letters* (with Allen Ginsberg) is published. In 1993 *Clean Asshole Poems and Smiling Vegetable Songs* is republished by Northern Lights.

Books: *Clean Asshole Poems and Smiling Vegetable Songs* (1978, 1993), *Straight Hearts' Delight* (with Allen Ginsberg, 1980).

LOU REED

b. Brooklyn, New York, 1943

Pl. 56

Rock musician. Poet. Studies with Delmore Schwartz at Syracuse University. From 1966 to 1970 singer, guitarist, and manager of Andy Warhol's group The Velvet Underground, recording three seminal rock albums, *Velvet Underground and Nico* (1967), *White Light, White Heat* (1967), *Velvet Underground* (1969). In the tradition of *Burroughs' *Junkie*, his songs deal with typical characters from among the fixers and gay community on the Lower East Side. Leaves Velvet Underground to pursue solo career. Has recorded more than twenty-five albums over the course of a career spanning three decades, including *Transformer* (1972), *Berlin* (1973), *Rock and Roll Animal* (1974), *Coney Island Baby* (1975), *Metal Machine Music* (1975), *Street Hassle* (1978), *Growing Up in Public* (1980), *The Blue Mask* (1982), *Legendary Hearts* (1983), *New Sensations* (1984), *The Bells* (1987), *New York* (1989), *Songs for Drella* (1990). *Between Thought and Expression*, a selection of his song lyrics, published in 1992.

BOOKS: *BETWEEN THOUGHT AND EXPRESSION* (1992).

ED SANDERS

b. Kansas City, Missouri, 1939

Pl. 68

Poet. Studies classical languages at New York University. Owner of the legendary Peace Eye Bookstore on the Lower East Side from 1962–65

and editor of *Fuck You: A Magazine for the Arts*. Publishes, among others, the Beat authors. From 1959 to 1969 founder, writer, and singer for the rock group The Fugs. Records eleven albums, many of them still in print. (The Fugs re-form in the eighties.) Has also recorded solo albums, most recently, *Songs in Ancient Greek* (1992). Experiments with electronic instruments. Pioneers poetry readings accompanied by music. Appears with mini-synthesizers of his own creation such as the "talking necktie" and "light organ." Long active in the social democrat wing of the counterculture in the sixties and seventies (publishes a number of influential magazines and manifestos). Active for past eighteen years in environmental, peace, economic justice, and consumer movements in Woodstock, upstate New York, where he lives and writes books of verse, poetics, collections of short stories, nonfiction, and libretti. *Thirsting for Peace in a Raging Century*, his selected poems, wins the American Book Award. *Star Peace*, his opera, recorded in 1986; *Cassandra*, a musical drama, is performed in 1992. *Tales of Beatnik Glory*, his affectionate memoirs, is soon to be a movie.

BOOKS: *POEM FROM JAIL* (1965), *PEACE EYE* (1966), *THE FAMILY: THE MANSON GROUP AND AFTERMATH* (1971; NEW EDITION, 1990), *TALES OF BEATNIK GLORY* (1971, 1990), *INVESTIGATIVE POETRY* (1976), *TWENTY THOUSAND A.D.* (1975), *FAME AND LOVE IN NEW YORK* (1980), *THE Z D GENERATION* (1981), *THE CUTTING PROW* (1983), *HYMN TO MAPLE SYRUP AND OTHER POEMS* (1985), *THIRSTING FOR PEACE IN A RAGING CENTURY: SELECTED POEMS, 1961–85* (1987, AWARDED THE AMERICAN BOOK AWARD), *HYMN TO THE REBEL CAFE* (1993).

HARRY SMITH

b. Portland, Oregon, 1923
d. New York City, 1991
Page 15

Anthropologist, ethno-musicologist, bibliophile, innovative animator, painter, designer, filmmaker, metaphysician. Made over 1,500 recordings "for restricted scientific use," 120 cuts commercially released. Mr. Smith's work collecting and preserving American oral song literature and artifacts is a primary source for post-mid-century folk music revival; Bob Dylan and others drew inspiration from his historic American Folk Music collection made available on Folkways. First recordings of Charlie Parker. First recordings of Kiowa Peyote Ceremony. Early recordings of Ginsberg. Awarded a Grammy in 1991 for contributions to the recording industry. Equally celebrated as a filmmaker, one of the first to paint directly onto frame; produced twenty-three films, specializing in animated collages, underground cinema classics shown regularly at Jonas Mekas Anthology Film Archives in New York, "valuable works, works that will live forever—they made me gray" (Harry Smith).

GARY SNYDER

b. San Francisco, 8 May 1930
Pl. 43, 79

Poet and essayist, Oriental scholar, ecological and environmental activist. With poets Lew Welch and Philip *Whalen attends Reed College, Portland, Oregon. Studies sinology at University of California, Berkeley. Holiday jobs as lumberjack and forestry inspector. Becomes friendly with *Ginsberg and *Kerouac in 1955, is the model for Japhy Ryder, the hero of Kerouac's *The Dharma Bums*. Between 1956 and 1968 undertakes a formal study of Zen Buddhism in Japanese monasteries. Travels widely (from China to Alaskan wilds). Translated widely (from Stockholm to Beijing). Has translated classic Chinese and Japanese texts, by-product of three decades' Zen practice. Since 1968

has lived in Nevada City, California, on San Juan Ridge in the Sierra foothills. First volume of poems, *Riprap*, published in 1958. Pulitzer Prize for *Turtle Island* in 1975. *No Nature* (1992) collects "a life's devotion to language and the natural world." In 1986 is elected a member of the American Academy of Arts and Letters. Currently Professor in the English Department at U.C. Davis teaching literature and wilderness thought. Of himself he declares, "As a poet I hold the most archaic values, the fertility of the soil, the magic of animals, the power-vision of solitude, initiation and rebirth, love and ecstasy, the common work of the tribe."

BOOKS: *RIPRAP* (1958, 1965), *REGARDING WAVE* (1967), *BACK COUNTRY* (1968), *EARTH HOUSE HOLD* (1969), *RIPRAP AND COLD MOUNTAIN POEMS* (1969, 1990), *SIX SECTIONS FROM MOUNTAINS AND RIVERS WITHOUT END* (1970), *TURTLE ISLAND* (1974), *MYTHS AND TEXTS* (1978), *THE REAL WORK: INTERVIEWS AND TALKS 1964–1979* (1980), *AXE HANDLES* (1983), *LEFT OUT IN THE RAIN* (1986), *NO NATURE: NEW AND SELECTED POEMS* (1992).

RECORDING: *THERE IS NO OTHER LIFE*, S PRESS, TC (1975).

ANNE WALDMAN

b. New York City, 1945
Pl. 70

Poet. Early years spent in Greenwich Village. Attends Bennington College, Vermont. From 1968 to 1978 runs the St. Mark's Church Poetry Project and is described by *Newsweek* as the "lyric queen of the Lower East Side." Organizes weekly workshops and poetry readings with writers from all over United States. Edits in-house journal *The World* and edits and publishes *Angel Hair* magazine and books. Following visit to India in 1973 becomes a practicing Buddhist. Becomes pupil of Lama Chögyam Trungpa and together with *Ginsberg founds the Jack Kerouac School of Disembodied Poetics at Trungpa's Naropa Institute, Boulder, Colorado, the first purely Buddhist college in the Western world. In 1975 is featured in Bob Dylan's film *Renaldo and Clara*. The same year City Lights publishes her *Fast Speaking Woman*, beginnings of oratorical emphasis that increases in coming decade. Her poetry highlights the acoustic aspect of language and demands to be read aloud. "Her body is an instrument, her voice a flickering flame which rises out of it" (Allen Ginsberg). World traveler and performer (Europe, India, Latin America), has collaborated with dancers and musicians, rock and roll, video. She is the author of over thirty books and pamphlets as well as a number of anthologies. *Helping the Dreamer*, a large-scale selection of her poetry is published in 1988. Her long poem *Jovis* appears in 1993. Dharma scholar, poetry teacher, resident of Boulder, head of the Jack Kerouac School's Poetics Program since 1984, she is currently the director of the master of fine arts program there.

BOOKS: *GIANT NIGHT* (1970), *BABY BREAKDOWN* (1970), *NO HASSLES* (1971), *LIFE NOTES* (1973), *FAST SPEAKING WOMAN* (1975), *JOURNALS AND DREAMS* (1976), *CABIN* (1981), *FIRST BABY POEMS* (1983), *INVENTION* (1983), *MAKE UP ON EMPTY SPACE* (1984), *SKIN MEAT BONES* (1985), *THE ROMANCE THING* (1987), *BLUE MOSQUE* (1987), *HELPING THE DREAMER: NEW AND SELECTED POEMS 1966-1988* (1989), *NOT A MALE PSEUDONYM* (1990), *TROUBAIRITZ* (1993), *IOVIS* (1993).

RECORDINGS: *NON STOP*, S PRESS, TC (1976), *JOHN GIORNO AND ANNE WALDMAN*, GIORNO POETRY SYSTEMS, LP (1977).

PHILIP WHALEN

b. Portland, Oregon, 20 October 1923
Pl. 45, 46

Poet and Zen priest. 1943–46: U.S. Army Air Corps radio operator and mechanics instructor. Attends Reed College, Portland, Oregon, with

poets Gary *Snyder and Lew Welch, then works casual jobs in San Francisco. Meets *Ginsberg in 1955. Participant at celebrated Six Gallery poetry reading. Prototype figure in Kerouac's *Dharma Bums* (Warren Coughlin) and *Big Sur* (Ben Fagan). Between 1965 and 1971 studies Zen Buddhism in Kyoto, Japan. Ordained as a Zen priest at the Zen Center in San Francisco in 1973. Frequently elected abbot, including Zen Mountain Center in Tassajara Springs, California, in 1975; South Ridge Zendo, San Francisco, in 1981–82; and Dharma Sangha, Santa Fe, New Mexico, in 1984. Returned to San Francisco as Sensei (teacher), Hartford Street Center (1988). His first volume of poetry, *Self-Portrait from Another Direction*, was published in 1959. Since then numerous poems collected in *On Bear's Head* (1969) and *Heavy Breathing* (1980) and two novels (reprinted 1985).

BOOKS: *SELF-PORTRAIT FROM ANOTHER DIRECTION* (1959), *MEMOIRS OF AN INTERGLACIAL AGE* (1960), *LIKE I SAY* (1960), *MONDAYS IN THE EVENING* (1964), *EVERY DAY* (1965), *HIGHGRADE* (1966), *YOU DIDN'T EVEN TRY* (1968), *ON BEAR'S HEAD* (1969), *SEVERANCE PAY: POEMS 1967–1969* (1970), *SCENES OF LIFE AT THE CAPITAL* (1971), *IMAGINARY SPEECHES FOR A BRAZEN HEAD* (1972), *THE KINDNESS OF STRANGERS: POEMS 1969–1974* (1976), *DECOMPRESSIONS: SELECTED POEMS* (1978), *OFF THE WALL: INTERVIEWS* (1978), *THE DIAMOND NOODLE* (1979), *ENOUGH SAID: POEMS 1974–1979* (1980), *HEAVY BREATHING: POEMS 1967–80* (1983), *TWO NOVELS* (1985).

YEVGENY YEVTUSHENKO
b. Stanzia Zima, Siberia, 1933
Pl. 73

Internationally renowned poet, prose writer, filmmaker, social critic. Studied at the Gorki Institute for World Literature in Moscow. Following his criticism of Stalinism in *Station Sima* (1956) and his revelation of Russian anti-Semitism in *Babi Yar* (1961), became, along with poet Andrei Voznesensky, one of the rare symbols of officially tolerated cultural protest in postwar pre-*glasnost* Soviet Union. During his first trip West in the early sixties, due to impassioned reading style and parallels of cultural criticism, he and Voznesensky are heralded as the Russian equivalent of the writers of the Beat Generation. Walks tightrope, remaining within Writers' Union. Travels widely and is translated extensively, especially in the United States. First *Selected Poems* appears in 1962. *The Poetry of Yevgeny Yevtushenko 1953–1965* appears in 1965. *Collected Poems* appears in 1991. Writes prose response to recent political upheavals (*Fatal Half Measures*). Recent new career as filmmaker, makes major experimental feature *The Kindergarden*. Lives in Moscow. Has been friends with Ginsberg since 1961.

BOOKS: *SELECTED POEMS* (1962), *A PRECOCIOUS AUTOBIOGRAPHY* (1963), *YEVGENY YEVTUSHENKO: POEMS CHOSEN BY THE AUTHOR* (1967), *THE BRATSK STATION AND OTHER NEW POEMS* (1967), *STOLEN APPLES* (1971), *THE FACE BEHIND THE FACE* (1979), *ALMOST AT THE END* (1987), *COLLECTED POEMS* (1991), *FATAL HALF MEASURES: THE CULTURE OF DEMOCRACY IN THE SOVIET UNION* (1991).

ALLEN GINSBERG
b. Newark, New Jersey, 3 June 1926
Pl. 6, 10, 12, 16, 19, 26,
35, 36, 40, 41, 42, 44, 45, 66

Poet and untiring propagandist of the Beat Generation and Beat writings. Of Russian Jewish descent. His mother Naomi was a Marxist activist; she died in a psychiatric clinic. His father Louis was a high school teacher and wrote conventional poetry (*Louis Ginsberg: Collected Poems*, 1992).

Childhood and school years spent with parents in Paterson, New Jersey.

1943–48: His studies in political economy at Columbia University, New York, are frequently interrupted. He writes his first poems, as yet in rhyming verse, published as *The Gates of Wrath* in 1972.

1944: Becomes friendly with *Burroughs and *Kerouac.

1945: Allows Kerouac to stay overnight on the Columbia campus and is suspended; trains to become a merchant seaman.

1946: Gets to know Neal *Cassady.

1948: William Blake–like visions encourage him in his belief that his vocation lies in poetry. Is introduced to William Carlos Williams, who becomes his literary mentor.

1949: Unfortunate involvement with Herbert *Huncke's band of small-time thieves, as a result of which he is arrested and sentenced to eight months in a psychiatric clinic as an alternative to prison.

1950–54: Works in market research and opinion research in Manhattan and also does various casual jobs on newspapers and magazines.

1951: Gets to know Gregory *Corso.

1952: Arranges for publication of Burroughs' first novel, *Junkie*.

1953: Burroughs stays with him in New York during the autumn of 1953, and they work together on *The Yage Letters*.

1954: Trip to Mexico with stops in Miami, Havana, Chiapas, Mexico City. Settles in San Francisco. Gets to know Peter *Orlovsky, his lifelong companion.

1955: Writes *Howl*, organizes a public reading at the Six Gallery on 13 October, when *Howl* receives its first performance. The other poets present are Philip Lamantia, Michael McClure, Gary *Snyder, and Philip *Whalen. The national response to the reading marks the beginning of the media circus surrounding the Beat Generation.

1956: Becomes friendly with Robert *Creeley. Death of his mother, Naomi. *Howl* published by Lawrence *Ferlinghetti's City Lights Books.

1957: With Orlovsky, Corso, and Kerouac visits Burroughs in Tangier, after which they tour across Europe, visiting Spain, France, Italy, and Germany before spending six months in Paris. A court in San Francisco tries Ferlinghetti for publishing *Howl*, alleging the work is obscene, but the case ends with an acquittal. The appearance of Kerouac's *On the Road* further stirs up the media circus around Ginsberg and company.

1958: Expeditions from Paris to Holland and England. Returns to New York and takes part in poetry readings at Harvard, Columbia, and Princeton Universities.

1959: Involvement in production of Robert *Frank's film *Pull My Daisy*. Records *Howl* for Fantasy Records. Works on *Kaddish*.

1960: Travels to South America, taking in Chile, Argentina, Bolivia, and Peru in a search for *yage*.

1961: Takes part in Timothy *Leary's experiments with drugs. Together with Orlovsky visits Burroughs in Tangier. Continues journey to Greece, Israel, and Kenya.

1962–63: Eighteen months in India, staying in Calcutta and Benares and traveling round the country with Gary *Snyder as his guide.

1963: Visits Angkor Wat, Saigon, Hong Kong, and Japan before continuing journey to Vancouver Poetry Conference. In Japan a visionary experience opens his eyes to the Buddhist view of the world.

1965: A visit to the Eastern bloc countries takes him to the Soviet Union, Poland, Czechoslovakia. Crowned "King of the May" in Prague and deported by the secret police. His involvement in the first power demonstration at Berkeley marks his active support for the anti–Vietnam War movement.

1967: Takes part with Gary Snyder and Michael McClure in the "Human Be-In" in San Francisco. Travels to Europe, where he meets Ezra Pound in Venice and takes part in the "Dialectics of Liberation" conference in London, in addition to sharing a platform at the Albert Hall with Gregory Corso, Yevgeny *Yevtushenko, and Ernst Jandl in an anti-war reading. Speaks out in favor of legalizing psychedelic drugs before a committee of Congress in Washington, D.C., and is arrested at a demonstration outside the district recruiting office in Manhattan.

1968: Death of Neal Cassady. Takes part in the Yippie Life Festival to mark the Democratic Party convention in Chicago. In a demonstration outside the convention headquarters, he is arrested as one of seven ringleaders. Works on a musical setting of William Blake's *Songs of Innocence and Experience*.

1969: Death of Jack Kerouac.

1971: Visits Calcutta and the refugee camps in East Pakistan. Music lessons with Bob Dylan and Happy Traum. Sets a second series of Blake's poems to music.

1972: Becomes a student of the Tibetan lama Chögyam Trungpa; formal conversion to Buddhism. Visits Australia. Arrested at an anti-war demonstration during the Republican Party convention in Miami.

1973: Takes part in poetry conferences in Rotterdam and London; tours around England and Scotland.

1974: Elected a member of the American Academy of Arts and Letters. Receives National Book Award for *The Fall of America*. Harry *Smith records *First Blues*, Ginsberg's first independent musical composition. Lecture tour of Belgium and England. Teaching around England and Scotland. Together with Anne *Waldman founds the Jack Kerouac School of Disembodied Poetics at Trungpa's Naropa Institute in Boulder, Colorado (where he spends many subsequent summers).

1975: Accompanies Bob Dylan on his Rolling Thunder tour.

1976: *First Blues*, two-record set, with cover art by Robert *Frank, produced by John Hammond Sr.

1977: Nightclub troubadour (with Steven Taylor) in New York, Los Angeles, Boston. Publishes early *Journals*. Reads with Robert Lowell at St. Mark's Poetry Project, New York. Attends U.C. Santa Cruz Conference on LSD. Visits Kauai.

1978: Writes *Plutonian Ode*. Acts, sings Blake, and visits Kerouac's grave with Bob Dylan for film *Renaldo and Clara*. Is arrested at a demonstration outside the gates of a factory making fuses for atom bombs at Rocky Flats, Colorado.

1979: Several European tours accompanied by Steven Taylor. Reads and sings at Oxford, Heidelberg, Tübingen, and International Poetry convocations at Cambridge, Rotterdam, Amsterdam, Paris, Genoa, and Rome.

1980: Rome International Poetry Festival. Readings, lectures, and concerts in Holland, Hungary, Switzerland, Austria, Germany, and Yugoslavia.

1981: Mexico City International Poetry Festival. Readings and performance in Italy. Lectures at Modern Language Association convention at Institute for Policy Studies, Washington D.C. Reading at New York's 92nd Street Y. Records and sings live with rock group The Clash. Anniversary reading to mark "Twenty-five Years of *Howl*" held at Columbia University, New York.

1982: Attends Poetry Festival Managua. Composes "Declaration of Three" with Ernesto Cardinal and Yevgeny Yevtushenko. Completes "Unamerican Activities," PEN Club report on FBI harassment. Organizes Kerouac conference, "Twenty-five Years of *On the Road*" at the Naropa Institute. Takes part in the international UNESCO poetry festival "War against War" in Paris. Lecture tour of northern Europe and Scandinavia.

1983: Completes lecture tour of Copenhagen, Stockholm, Oslo, Helsinki, East and West Germany. Attends William Carlos Williams Centennial Conferences. Appointed Director Emeritus of the Jack Kerouac School in Boulder. Visits with Berenice *Abbott in Maine and New York.

1984: New Year's Day appears on Nam June Paik's "Good Morning, Mr. Orwell," live satellite television. Lecture tour of Belgium and England. Teaching collaboration, poetry music video, with Elvin Jones and Robert Frank, Atlantic Center for Arts, Florida. Travels to China as member of delegation from the American Academy of Arts and Letters and stays two months, travels, teaches, reads from his work in Beijing, Canton, Shanghai. Thirty years' photograph archives indexed and newly printed, advised by Robert Frank. *Collected Poems 1947–1980* is published.

1985: First photography exhibitions, "Hideous Human Angels" at the Holly Soloman Gallery, New York, and "Memory Gardens" at the Middendorf Gallery, Washington D.C. Travels to the Soviet Union as member of a delegation from the American Academy of Arts and Letters. Reads from his work in Moscow, where Yevtushenko acts as his translator.

1986: Takes part in the international PEN conference in New York. With Arthur Miller and Günther Grass signs protest against American involvement in Nicaragua. Harper Collins publishes an *Annotated Howl* and *White Shroud*, new poems. *Best Minds*, festschrift, published to celebrate his sixtieth birthday. Lecture tour of Hungary, Yugoslavia, and Poland. In Yugoslavia at the Struga Poetry Festival he is awarded the Golden Wreath. Begins appointment as Visiting Professor at Brooklyn College, New York (later to become full tenured professor).

1987: Photograph exhibits in Miami; Dallas; Lawrence, Kansas; Graz, Austria; Arhus, Denmark (first photo collection, *Allen Ginsberg, Fotografier 1947–87*). Brooklyn College presents "Literary History of Beat Generation." Visits with Chögyam Trungpa in hospital. Chögyam Trungpa dies. Visits Mississippi Delta ("Ole Miss" Southern Folklore Center Blues Archive, Oxford and Clarksdale, with Harry Smith). Attends River City Reunion, Lawrence, Kansas; Twentieth Anniversary St. Mark's Poetry Project, New York; Francophone Kerouac Convention, Quebec. *Lion for Real*, spoken word/music album recorded by Hal Wilner. Addresses Buddhist Psychotherapy Conference, New York. Organizes PEN, ACLU, and Pacifica Radio opposition to FCC censorship of arts broadcasting.

1988: Readings in Israel, meeting with prominent Palestinians, addresses 60,000 at Peace Now Rally. Teaches "Photographic Poetics" at Brooklyn College. Collaboration with composer Philip Glass, *Wichita Vortex Sutra* premiers at New York's Lincoln Center. *Cosmopolitan Greetings*, directed by Robert Wilson, libretto by Allen Ginsberg, opens at Hamburg State Opera House. Tours Japan (readings in Tokyo, Osaka, Seika, and Kyoto). Reads with "Poets from the People's Republic of China" at the Museum of Modern Art in New York. Reads at Kerouac Commemorative Park, Lowell, Massachusetts. Gives the Charles Olson Lectures at State University of New York, Buffalo. Attends Translators Conference, Barnard College, New York. Gives seminar "Snapshot Poetics" at Zen Mountain Monastery, New York. Photo exhibits: Tokyo, Krakow, Warsaw, Tübingen, New York, Lowell, Boston, Cambridge.

1989: Various high school and college poetry readings throughout the United States—Utah, Amherst, Albion, Duke. Benefit readings. Teaching. Performing. California: Harmonium Mundi Conference with Dalai Lama, San Francisco National Poetry Association Week Award. Wins federal appeal against FCC ban on transmission of *Howl* over the airwaves. Publication of first full-scale biography (*Ginsberg*, by Barry Miles). Poems and interview in *Paris Review*. Publication of *Reality Sandwiches* (second photography collection). Photo exhibits: Los Angeles, Chicago, Vienna, Hamburg, Bremen, Ludwigsburg.

1990: Lectures at Rutgers University, New Jersey, "Photography and Poetics." Speaks at Earth Day Rally, Philadelphia. Returns to Prague after twenty-five years, received by President Havel, recrowned "King of May," lectures at Charles and Olomuc Universities. Premiere of *Hydrogen Jukebox*, opera with Philip Glass (Spoleto Festivals, Charleston, South Carolina, and Spoleto, Italy). Readings in London and Paris. American delegate to Twelfth World Congress of Poets, Seoul, South Korea. Lectures on censorship at Boston Museum of Fine Art and on pharmacology, State University of New York, Albany. Inauguration of traveling photo exhibit, FNAC Galeries, Paris. Presented with Lifetime Achievement Award by the Before Columbus Foundation, Miami, Florida.

1991: Lectures at Virginia Military Institute, St. Mark's Poetry Project, Shambhala Training Center, Walt Whitman Birthplace Association, Karma Triyana Monastery, Paterson Great Falls Preservation and Development Corporation (200th Anniversary), New York Academy of Sciences, Modern Language Association, Kenyon College, Pitzer College, Naropa Institute, and elsewhere. Presented with the Harriet Monroe Poetry Award from the University of Chicago. Long-awaited first American fine art edition of Ginsberg's photographs, *Allen Ginsberg: Photographs*, is published by Twelvetrees Press, Santa Fe, New Mexico.

1992: Lecture/Demonstration, International Center for Photography, New York City. Visits Europe. Participates in the Jewel Heart Benefit Readings with Anne Waldman and Gelek Rinpoche. Lectures and readings at the National Poetry Foundation, University of Maine, Santa Monica Writers Conference. Walt Whitman Centenary Celebrations. Presentation of the Chevalier de l'Ordre des Artes et des Lettres by French Minister of Culture, Jacques Lang. Elected Fellow of the American Academy of Arts and Sciences. New volumes of poetry in China, Czechoslovakia, Bulgaria. Publication of Michael Schumacher's extensive biography, *Dharma Lion*.

1993: Tours American heartland—Boise, St. Louis, Phoenix, Lexington, Lincoln. Readings and performances at universities and colleges. Fiftieth high school class reunion at East Side High School in New Jersey. Attends Judaism and Buddhism conference with Zalman Schachter and Gelek Rinpoche, conference on 1930s poets at National Poetry Foundation, Maine. Brooklyn College, Naropa Institute. August Jewel Heart Retreat with Gelek Rinpoche before extensive four-month tour—Austria; Hungary; Poland; first visit to Ireland, reading in Dublin and Belfast, readings in Oslo, Munich, Paris, Berlin, Prague, Barcelona, Madrid, Cordoba, Athens. Final stop Tangier, for visit with Paul Bowles before returning to Vajrayogini retreat.

BOOKS—POETRY: *HOWL AND OTHER POEMS* (1956), *KADDISH AND OTHER POEMS* (1961), *EMPTY MIRROR: EARLY POEMS* (1961), *REALITY SANDWICHES* (1963), *ANKOR WAT* (1968), *AIRPLANE DREAMS* (1968), *PLANET NEWS* (1968), *THE GATES OF WRATH: RHYMED POEMS 1948–51* (1972), *THE FALL OF AMERICA: POEMS OF THESE STATES* (1973), *IRON HORSE* (1974), *MIND BREATHS: POEMS 1971–76* (1978), *POEMS ALL OVER THE PLACE, MOSTLY '70S* (1978), *PLUTONIAN ODE: POEMS 1977–80* (1982), *COLLECTED POEMS: 1947–1980* (1984), *WHITE SHROUD: POEMS 1980–85* (1986), *HOWL ANNOTATED* (WITH FACSIMILE MANUSCRIPT, 1986), *COSMOPOLITAN GREETINGS: POEMS 1986–1993* (1994).

PROSE: *THE YAGE LETTERS* (WITH WILLIAM BURROUGHS, 1963), *INDIAN JOURNALS* (1970), *GAY SUNSHINE INTERVIEW* (1974), *ALLEN VERBATIM* (1974), *THE VISIONS OF THE GREAT REMEMBERER* (1974), *TO EBERHART FROM GINSBERG* (1976), *JOURNALS EARLY FIFTIES, EARLY SIXTIES* (1977), *AS EVER: COLLECTED CORRESPONDENCE OF ALLEN GINSBERG AND NEAL CASSADY* (1977), *COMPOSED ON THE TONGUE* (1980), *STRAIGHT HEARTS' DELIGHT* (WITH PETER ORLOVSKY) (1980), *YOUR REASON AND BLAKE'S SYSTEM* (1988).

RECORDINGS: *HOWL AND OTHER POEMS*, FANTASY, LP (1959), *KADDISH*, ATLANTIC VERBUM, LP (1966), *WILLIAM BLAKE'S "SONGS OF INNOCENCE AND EXPERIENCE" TUNED BY ALLEN GINSBERG*, MGM, LP (1970), *FIRST BLUES*, FOLKWAYS, LP (1981), *FIRST BLUES: SONGS*, COLUMBIA DOUBLE ALBUM, LP (1983), *A LITTLE BIT OF AWARENESS*, S PRESS, TC (1980), *GERMAN TOUR*, S PRESS, TC (1980), *THE LION FOR REAL*, ISLAND, TC, LP, CD (1990), *HOLY SOUL JELLY ROLL: POEMS AND SONGS 1949–1993*, RHINO RECORDS, CD (1994).

BIOGRAPHIES: BARRY MILES, *GINSBERG* (1989), MICHAEL SCHUMACHER, *DHARMA LION: A CRITICAL BIOGRAPHY OF ALLEN GINSBERG* (1992).

FILM/VIDEO: *THE LIFE AND TIMES OF ALLEN GINSBERG*, DIRECTED BY JERRY ARONSON (1994).

PHOTOGRAPHY BOOKS AND CATALOGUES: *ALLEN GINSBERG FOTOGRAFIER* 1947–87 (1987), *REALITY SANDWICHES* (1989), *ALLEN GINSBERG PHOTOGRAPHS* (1991), *SNAPSHOT POETICS* (1993).

EXHIBITIONS: HOLLY SOLOMAN GALLERY, NEW YORK CITY, JANUARY 1985
NEW YORK PUBLIC LIBRARY, "NEW ACQUISITIONS: PHOTOGRAPHS," NEW YORK CITY, FEBRUARY 1985 (GROUP SHOW)
MIDDENDORF GALLERY, WASHINGTON, D.C., APRIL 1985
FORUM STADTPARK, GRAZ, AUSTRIA, OCTOBER 1968 (GROUP SHOW)
BOOKS & BOOKS, CORAL GABLES, FLORIDA, JANUARY 1987
DALLAS MUSEUM OF ART, DALLAS, TEXAS, JANUARY 1987
GALERIE WATARI, TOKYO, JAPAN, APRIL 1987
NAROPA INSTITUTE, BOULDER, COLORADO, JULY 1987
KELLAS GALLERY, LAWRENCE, KANSAS, SEPTEMBER 1987
MUSÉE DU QUEBEC, QUEBEC CITY, QUEBEC, OCTOBER 1987 (GROUP SHOW)
IMAGE GALLERY, DENMARK, NORTHERN EUROPE, POLAND, FALL 1987
CAMERA OBSCURA SCHOOL OF ART, TEL AVIV, ISRAEL, JANUARY 1988
FOGG MUSEUM, CAMBRIDGE, MASSACHUSETTS, MARCH 1988
SOCIETY OF ART PHOTOGRAPHERS, KRAKOW, POLAND, MARCH–APRIL 1988
MALA GALLERY, WARSAW, POLAND, 1988
WHISTLER HOUSE MUSEUM, LOWELL, MASSACHUSETTS, JUNE–AUGUST 1988
VISION GALLERY, BOSTON, MASSACHUSETTS, OCTOBER 1988
STADTTHEATER, TÜBINGEN, GERMANY, DECEMBER 1988
FORUM BÖTTCHERSTRASSE, BREMEN, GERMANY, MAY–JUNE 1989
CATHERINE EDLEMAN GALLERY (WITH ANNIE LEIBOVITZ), CHICAGO, ILLINOIS, JULY 1989
KAMPNAGEL FABRIK, HAMBURG, GERMANY, AUGUST–SEPTEMBER 1989
GALERIE FABER, WIEN, AUSTRIA, SEPTEMBER–OCTOBER 1989
FAHEY/KLEIN GALLERY, LOS ANGELES, CALIFORNIA, NOVEMBER 1989
SCALA THEATER, LUDWIGSBURG, GERMANY, NOVEMBER–DECEMBER 1989
FOTOFEST '90, HOUSTON, TEXAS, FEBRUARY 1990
FORUM DER KAMMERSPIELE, EAST BERLIN, GERMANY, APRIL 1990
MUNICIPAL GALLERY, ERLANGEN, GERMANY, JUNE 1990
CASA SIN NOMBRE (WITH WILLIAM S. BURROUGHS), SANTA FE, NEW MEXICO, JULY 1990
FNAC GALERIES, PARIS, FRANCE, OCTOBER–DECEMBER 1990
FNAC GALERIES, STRASBOURG, FRANCE, JANUARY–FEBRUARY 1991
BRENT SIKKEMA FINE ART, NEW YORK, MARCH–APRIL 1991
FNAC GALERIES, LYON, FRANCE, APRIL–MAY 1991
FNAC GALERIES, BORDEAUX, FRANCE, JULY–AUGUST 1991
CORTLAND JESSUP GALLERY, PROVINCETOWN, RHODE ISLAND, AUGUST 1991
ROBERT KOCH GALLERY, SAN FRANCISCO, CALIFORNIA, AUGUST–SEPTEMBER 1991
CLEVELAND CENTER FOR CONTEMPORARY ART, CLEVELAND, OHIO, SEPTEMBER–OCTOBER 1991
FNAC GALERIES, PARIS, FRANCE, NOVEMBER 1991–JANUARY 1992
CANON GALLERY, AMSTERDAM, THE NETHERLANDS, JANUARY 1992
FNAC GALERIES, MULHOUSE, FRANCE, FEBRUARY–APRIL 1992
KREN GALLERY, COLOGNE, GERMANY (WITH ROBERT RAUSCHENBERG), APRIL 1992
FNAC GALERIES, TOULOUSE, FRANCE, JULY–SEPTEMBER 1992
FNAC GALERIES, GRENOBLE, FRANCE, NOVEMBER–DECEMBER 1992
FNAC GALERIES, LYON, FRANCE, DECEMBER 1992–JANUARY 1993
FNAC GALERIES, MONTPELLIER, FRANCE, MAY–JUNE 1993
FNAC GALERIES, LILLE, FRANCE, AUGUST 1993–OCTOBER 1993
BEURSSCHOUWBURG, BRUSSELS, BELGIUM, MARCH 1994

MICHAEL KÖHLER After American Studies at the Universities of Munich and Yale, freelance writer and exhibition curator. Since 1970, producer of S Press Tapes, an international documentation of acoustic literature. Has known Ginsberg since 1974 when they worked together on a recording for S Press Tapes. Organized reading tours for Ginsberg in Germany in the late 1970s and a retrospective of Ginsberg's photographs for touring in Europe in the late 1980s. Recently completed a pictorial biography of William S. Burroughs.

BOOKS: *DAS AKTPHOTO* (1985), *ANSICHTEN VOM KÖRPER* (1978). *DAS KONSTRULERTE BILD* (1989), *BURROUGHS–EIN BILDBIOGRAFIE* (1994).

the end.